C000080230

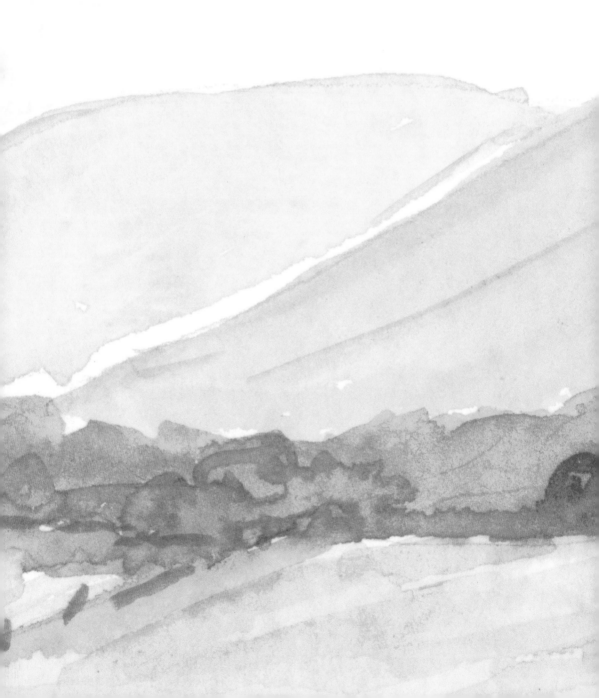

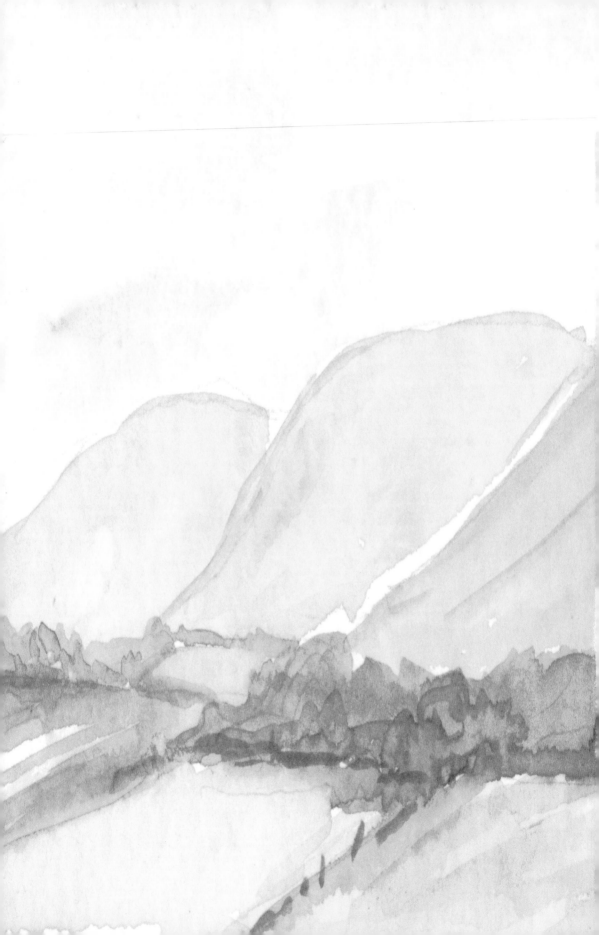

# The
# SOUTH
# DOWNS

*A Painted Year*

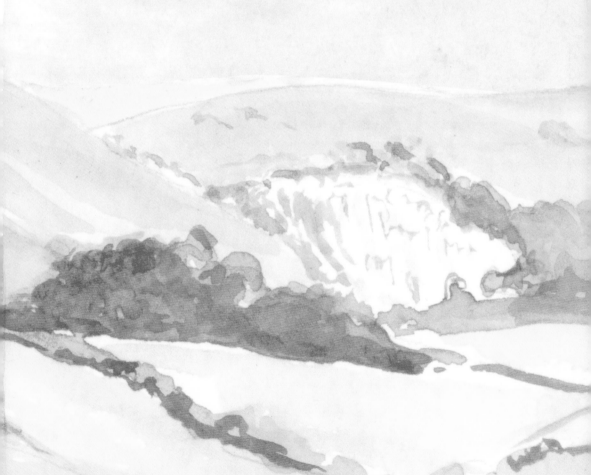

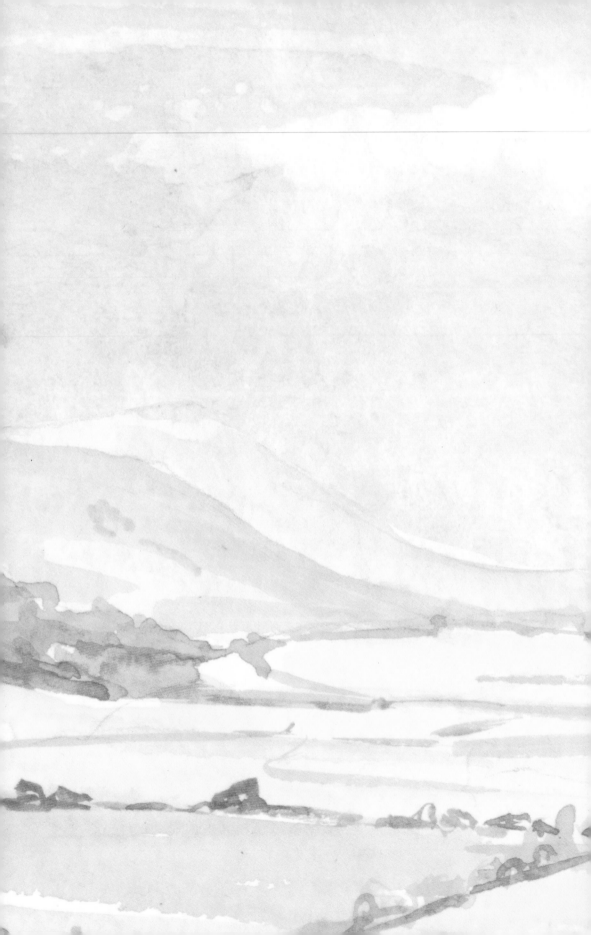

# The
# SOUTH DOWNS

*A Painted Year*

ANTONIA DUNDAS

AMBERLEY

First published 2011

Amberley Publishing
The Hill, Stroud,
Gloucestershire, GL5 4ER

www.amberleybooks.com

British Library Cataloguing in Publication Data.
A catalogue record for this book is available from the British Library.

ISBN 978 1 4456 0073 4

Typesetting and Origination by Amberley Publishing
Printed in Great Britain

# Foreword

I HAVE LIVED IN OR NEAR the South Downs of West Sussex for more than sixty years during which time I have ridden or walked along their many paths and tracks as well as those of the surrounding countryside. Recently, I decided that I would combine my interest and concern for the local wildlife and my love of the area with my ability to draw and paint, together with my other passions for riding and walking and produce a book illustrated with my own pictures as a monthly record of the local countryside at the beginning of the twenty-first century.

I have seen many changes in these years. When I was a child the Downs were almost deserted, apart from the people who worked on them. I used to know the local farmers, and had many friends among the shepherds, pig-men, tractor-drivers and gamekeepers, and would stop to chat to them as I rode by. I would rarely meet other walkers or riders and for many years have escaped from the humdrum of modern life by taking my horse or dogs up the hill and through the woods and on the rolling downlands. However, things change and now many people enjoy this area in lots of different ways. I hope that by reading my notes and seeing my pictures they will regard some of the humbler species in a different light and see beauty in the wayside even on the very bleakest days. I hope to describe the flora and fauna that they might well see on a walk, ride on a horse, a bicycle or even from a car.

Over the years I have taken much of the wildlife for granted, but in putting this book together I have learnt to appreciate the many hundreds of different animals, flowers, butterflies, birds, insects, fungi, trees and even reptiles that one could come across. I would not pretend to be an expert and my knowledge is basic, but I have tried to cover everyday sights for the walker to look out for – along with the odd rarity. From the back of a horse one has a good vantage point and I often stop, look and listen and I gather leaves and branches from the hedgerows to paint when I get home. As an artist I think I have learnt to look at things differently. Now I feel that it is important to leave something behind for the generations to come.

Antonia Dundas

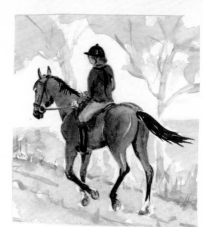

# THE PAINTED YEAR

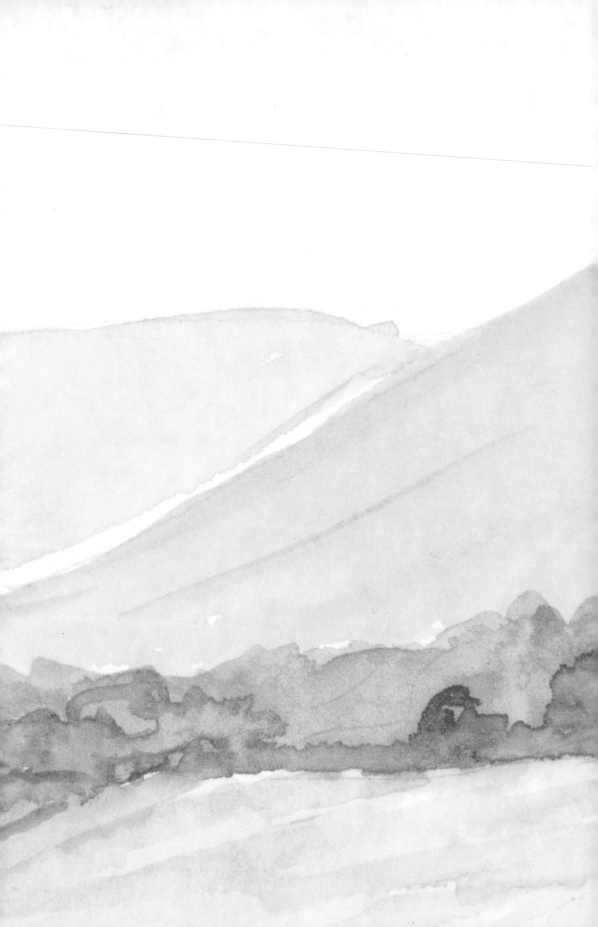

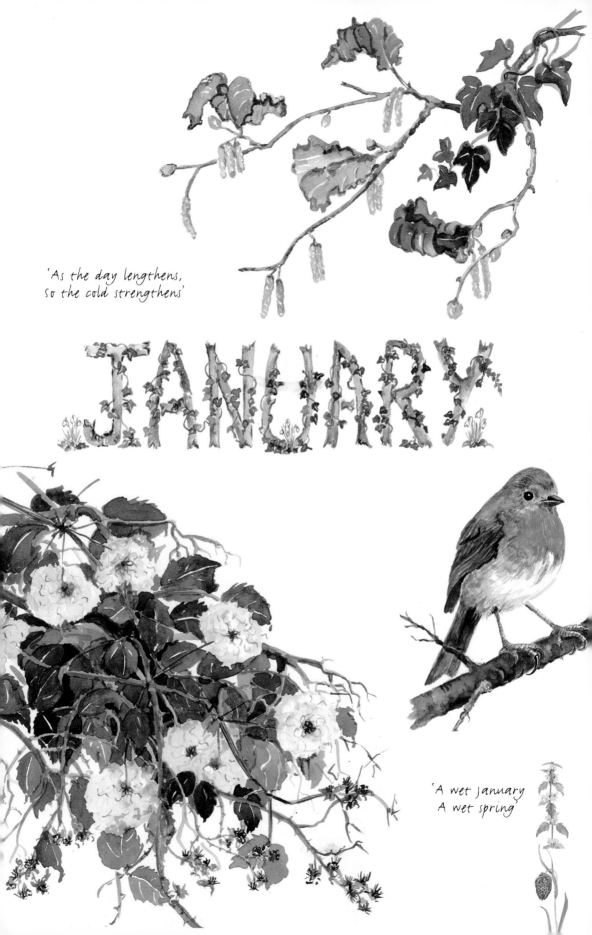

'As the day lengthens,
so the cold strengthens'

# JANUARY

'A wet January
A wet spring

JANUARY is a month when the days can vary from bright and frosty with sparkling sunlight and blue skies to those which are dull, damp and dark with leaden skies. Although snow can come any time from November to April it is more likely now or in February. It seldom lasts long in the South. Now is a good time to see the birds in the bare undergrowth.

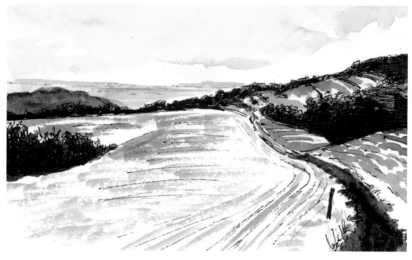

A WINTRY VIEW The downs are chalk uplands formed in the cretaceous period 120-75 million years ago. There are lots of ancient burial grounds and earthworks along their length. There are many flints and Neolithic man discovered that these made excellent tools and weapons. They used to be covered with beech woods and yew forests. The shallow easily drained soil makes them very suitable for arable cultivation.

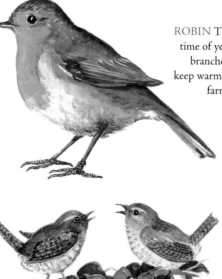

ROBIN These familiar birds are always associated with this time of year. Their bright breasts are easily seen in the bare branches. They fluff out their feathers in cold weather to keep warm. They love company and live around gardens and farms. They are very territorial and are heard singing noisily in the spring.

WREN These little birds are often seen hopping and bobbing in the undergrowth. They flit and climb about feeding on minute insects. Identified by their dark red-brown plumage with black bars and a short upturned tail, they have a loud, clear, high trilling voice and a rattling alarm call and they whirr their wings in flight. They nest in crevices and holes in trees and bushes. Wrens don't like the cold and huddle together for warmth. Folklore warns that if you harm a wren something awful will happen to you.

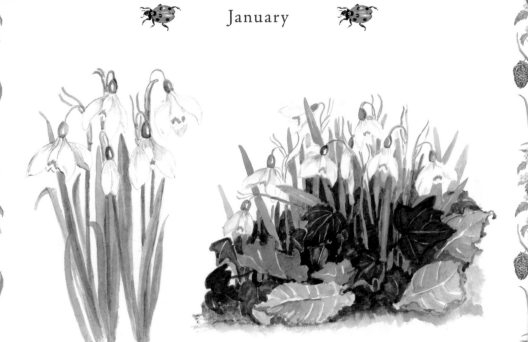

SNOWDROP These are the first flowers of the year and can be seen flowering as early as the first week in January. They used to be called Candlemas Bells because they were known to flower on Candlemas Day, 2 February. They are normally found near gardens or habitation but can be found wild in large patches in coppices and on banks beside tracks and roads.

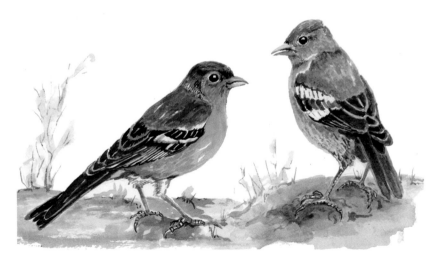

CHAFFINCH These attractively coloured birds are a common sight in the local hedgerows. The males have striking pink underparts and blue-grey heads. The female is a dull version of the male. They both have double white wing bars which makes them recognisable in flight. They make a familiar 'pink' call.

POLLARDING In bygone days trees were often pollarded. They were cut six feet or so from the ground, meaning young shoots were well clear of the ground and out of the reach of cattle and deer. The small poles were used for fencing, baskets and firewood.

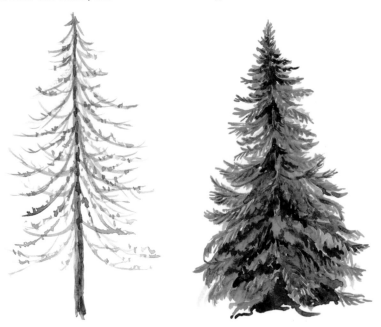

LARCH (*left*) This is the only deciduous conifer and sheds its leaves in autumn. It has graceful branches with knobs on its twigs. In spring each knob bears a tuft of needles. It has a small purple flower in early April and rosette-shaped cones in autumn.

DOUGLAS FIR (*right*) These evergreens are native to North America and introduced to Europe in 1828. It is identified by its graceful branches, sharp reddish buds and flat needles.

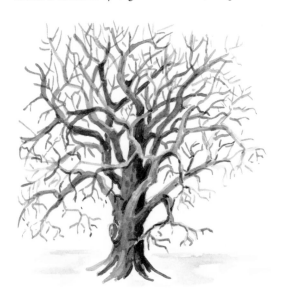

OAK This handsome tree is prolific all over the country, particularly in the South. The tree is slow-growing but has a vast root structure and can grow up to great heights and live for hundreds of years. Its branches provide food and shelter for many birds and insects. Many ancient trees came down in the 'Great Storm' of 1987. Apart from its shape the oak is identified by its lobed leaves, pendant catkins in spring, and acorns in the autumn.

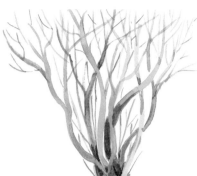

HAZEL (*above*) This is a spreading bush which has many uses. Many have been coppiced over the years making them send up a mass of shoots, long flexible branches which were used for pea and bean sticks, hurdles, kindling wood, and pegs used for thatching. If hazel is not coppiced it grows into a tall, often rather scruffy, bush. It has yellow catkins in February and buds with crimson tassels in April.

SILVER BIRCH (*right*) This elegant tree has been native to this country since the Ice Age. It can be found anywhere but it is most common on sandy soil. It is one of the hardiest trees in the world growing high on mountainsides. Its long, thin branches used to be made into besom-brooms, faggots, and baskets.

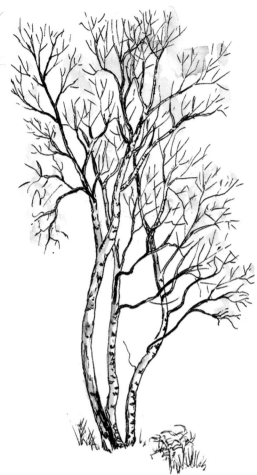

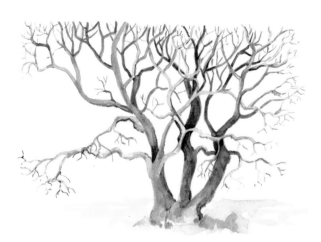

ASH This is a common tree which can grow very tall. It has a smooth grey bark and its leaves are late to emerge in the spring. Many old ash trees are like this one and were coppiced when young with the branches growing out from the trunk. It bends easily after steaming and has been used to make furniture. Ash wood is very good for burning.

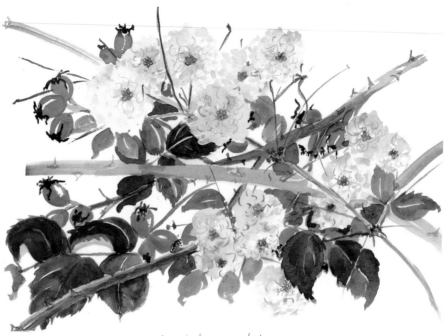

*A typical January hedgerow*

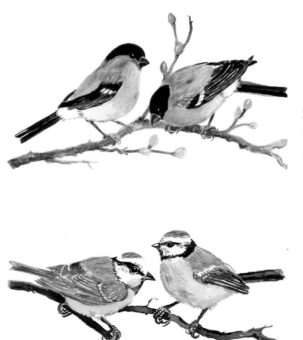

BULLFINCH These birds are quite rare these days and are found in dense areas of undergrowth. The male has a lovely pink breast with a grey back and glossy blue-black head, wings, and tail. The female has the same basic pattern but without the pink breast and in muted colours. Both sexes have a white rump which is seen in flight. They have a short, thick bill which is perfect for seeds and berries. They often feed on the ground.

BLUE TIT These familiar birds are numerous around the villages and gardens in winter, feeding off bird-tables and in the hedges and woods in summer. They nest in holes in trees, where they eat seeds and insects.

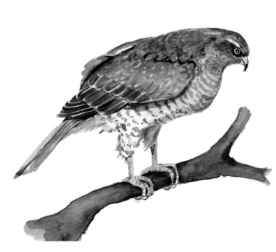

SPARROWHAWK These are a common bird of prey, often seen by the side of roads and tracks, perching high on branches or telegraph poles, ready to swoop down on small mammals. They also catch small birds in flight – hen sparrowhawks will even kill a pigeon. It is identifiable by its long barred tail.

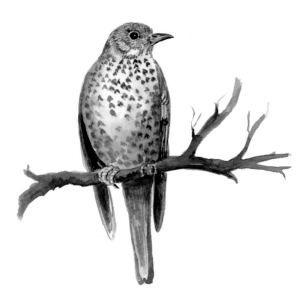

MISTLE THRUSH This is the biggest of the thrushes also known as the Storm Thrush or Storm Cock due to its habit of singing before storms. They are becoming uncommon. They live in open fields and hedgerows, eating berries, fruit, and insects, and listening for worms. They are handsome, bold, and quarrelsome, guarding their particular bush of berries. They are distinctly lighter coloured than the song thrush and make a harsh rattling alarm call.

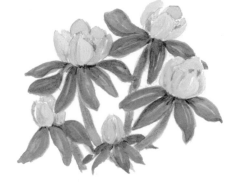

WINTER ACONITE These were introduced from Europe, and are related to Monkshood, so are poisonous. They are found in copses. The flowers open in sunshine and shut in shade.

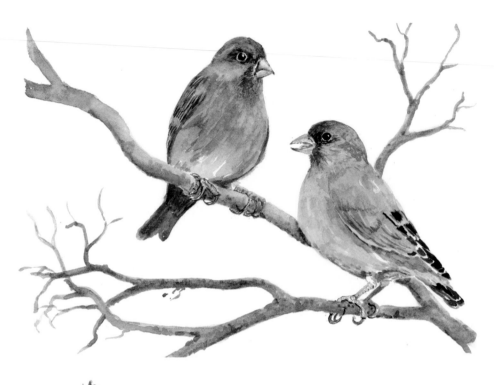

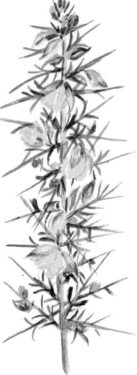

GREENFINCH These attractive birds are quite numerous and can be seen in flocks on stubble fields. The male has bright yellowy-green plumage with yellow wing patches. The female is much duller. They make a harsh, wheezy call, and nest in dense foliage. They eat seeds with their stout, powerful beaks.

GORSE This bush is found in uncultivated areas of scrub and turf. The old saying 'When gorse is out of bloom, kissing is out of season' and 'I'll pay my bills when gorse is out of flower', means that there are always some flowers on gorse all the year round. The two maximum flowering seasons are February to May and August to September. It used to be called Yellow Whin. Although common and unloved due to its spikes it had many uses in olden times. Highly inflammable, it is a good fuel. Bundles of furze stems were made into faggots and sent into town for domestic hearths and also used in the furnaces for firing bricks and tiles. Young strong shoots were crushed and used to feed animals in severe winters. It was said that if given to a horse that was off its food, gorse would help it to recover.

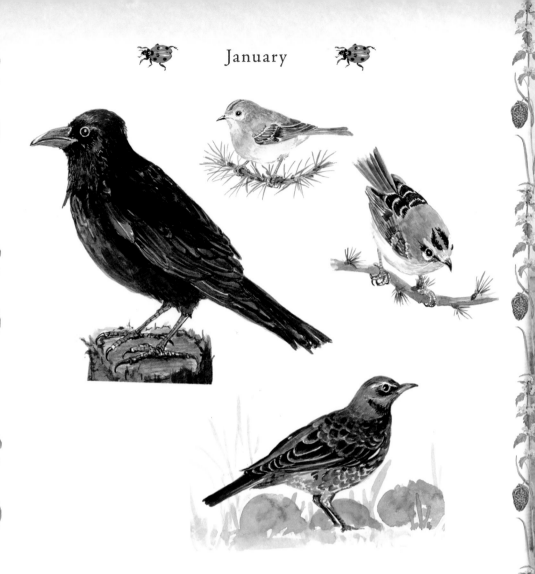

*Clockwise from left:*

CARRION CROW These birds will survive the winter by scavenging for anything edible – carrion, insecs, worms, and seeds. They will dig in the earth with their strong beaks and are often seen around deer, sheep, and cattle, eating ticks off their backs. They sometimes raid other birds' nests for eggs. They are often seen in pairs and move on the ground in hops and leaps. In the air they fly straight, thus the saying 'as the crow flies'.

GOLDCREST Along with its close relation the Firecrest, this is the smallest British bird. They are hard to identify but have a shrill, peeping call. They usually live in conifer woods building basket-like nests high in the trees. These little birds flit continuously in the undergrowth, feeding on flies and small insects. They do not survive hard winters.

FIRECREST Similar to the Goldcrest but it has a lighter underside with a broader, blacker cap and thin orange strip and a white stripe above the eye.

FIELDFARE This is a large thrush and a winter visitor, often seen in large flocks mixed with redwings. It has a grey head, chestnut back, pale spotted underparts, and a yellowish breast. In flight it is recognisable by its white underwings.

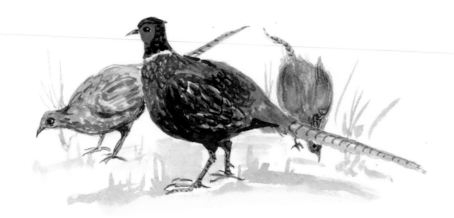

PHEASANT These birds were first imported here by the Romans and are now very common as there are many bred for shooting all over the country. They feed on grain, berries, acorns, wireworm, and insects and nest in grassy hollows in April, laying twelve-fourteen green-brown eggs. They roost in trees at night and feed on arable land and pasture during the day. They crouch when approached. If they have to move they rise suddenly, making a loud cackling sound in alarm.

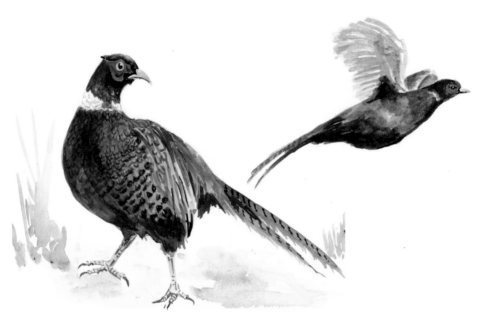

Most of us take these commonly seen birds for granted but the cockbirds can be particularly handsome, with feathers in many different colours. Apart from their iridescent green and blue heads and red wattles, often accentuated by a white ring around their necks, their backs have feathers which vary from a turquoise, light green or reddish-purple sheen. Their chests are a rich chestnut and black. The female is smaller with light brown plumage, shorter tails, and no spurs.

Very dark pheasants are called melanistic. These have dark green and blue feathers. One can occasionally see golden pheasants which have escaped from private collections. I have used pheasants' feathers to make collages, so I appreciate their variety and beauty. They never fade.

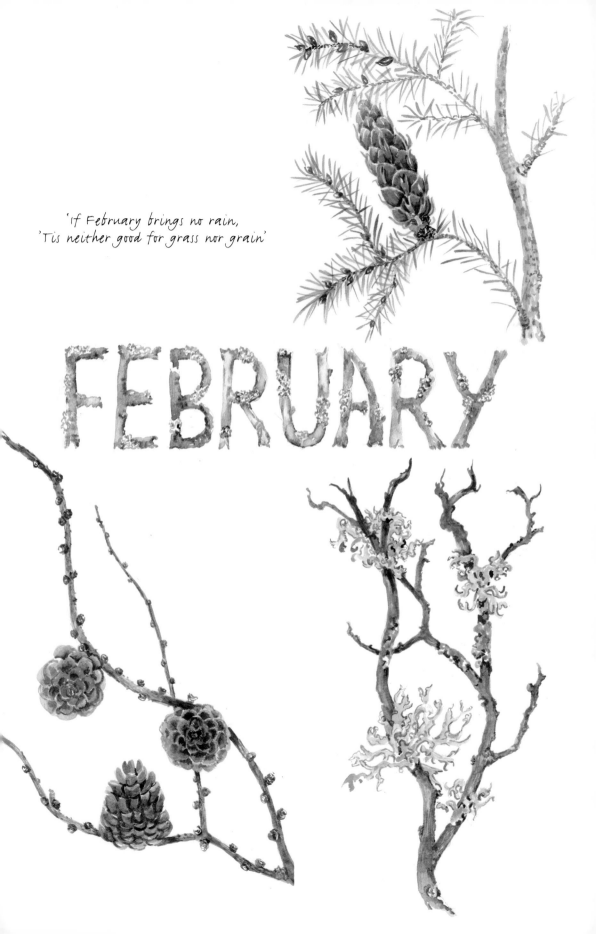

'If February brings no rain,
'Tis neither good for grass nor grain'

# FEBRUARY

FEBRUARY is often the coldest month of the year. Food can be in short supply for the birds and small mammals. There is not much colour in the hedgerows, but nevertheless lots to look at and collect to paint. Moss covered logs, lichen covered branches, and fir cones make interesting subjects.

FLINTS These are found all over the South Downs. They are a crystalline silica and come in lovely black, grey/blue, and brown colours. When dug from the chalk the outside is often a dull grey-white. They come in lots of different shapes. An essential raw material in prehistoric times, it was chipped to make scrapers, spearheads, axes, and arrowheads. It produces sparks when struck by another flint or ironstone.

COLLARED DOVE (*left*) These birds have become very common in farmyards and gardens. They are similar to pigeons but have paler plumage and a black collar. It is said that they pair for life.

LICHEN (*below*) It is a dual plant formed by a fungus and an alga plant. There are many different lichens, most of which grow on shrubs and trees. It looks beautiful on old bare hazel or hawthorn branches in the winter months. It has been found that lichens are rarer in towns than in the countryside which is thought to be due to air pollution.

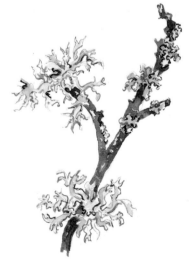

'If Candlemas Day be fair and bright,
Winter will have another flight
But if Candlemas Day be clouds and rain,
Winter is gone and will not come again'

CANDLEMAS DAY – 2 FEBRUARY

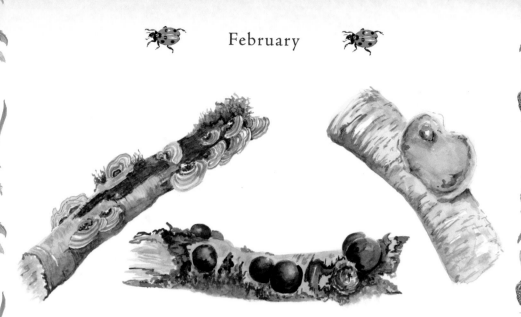

*Left to right:*

MANY-ZONED POLYPORE A very common bracket fungus growing on dead stumps and fallen branches.

KING ALFRED'S CAKE Hard knobbly balls are formed on dead and dying branches of deciduous trees, particularly ash.

BIRCH POLYPORE Bracket fungus found on dead birch trunks.

CATKINS AND IVY These make an attractive arrangement for painting. In cold winters the birds have already eaten the ivy berries, their leaves are a dark, glossy green.

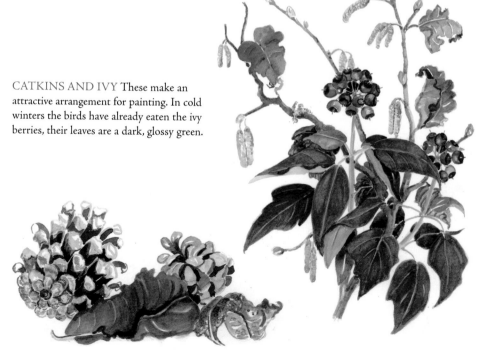

*Fir cones and dead leaves*

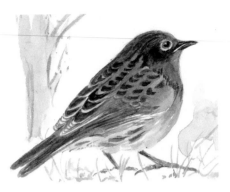

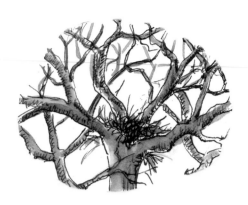

DUNNOCK (*left*) This is a rather dull little bird, easily confused with a female sparrow, which used to be called the hedge sparrow. It is chestnut brown and black with a purplish-grey look. It has a high piping song and will sing if it is woken at night. It feeds on the ground on seeds and insects. They are polygamous and can have several mates, and nest in grassy cups in low bushes.

SQUIRREL'S DREY OR NEST (*right*) These untidy clumps of twigs perched high in the trees can be mistaken for bird's nests. Squirrels live in these in the winter. The dreys are lined with grass and leaves.

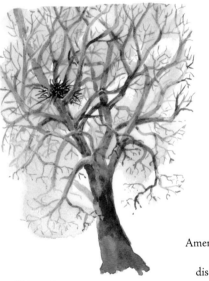

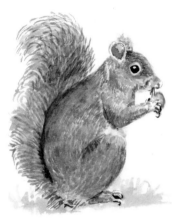

GREY SQUIRREL These were introduced from America in 1870 and are now widespread. Red squirrels, which are indigenous here, died from an epidemic disease to which the greys adapted. Squirrels breed in early spring, usually having two broods of 2-3 'kittens'.

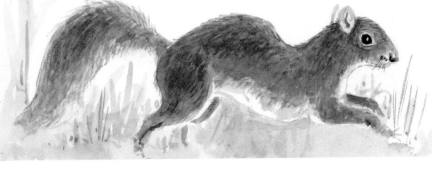

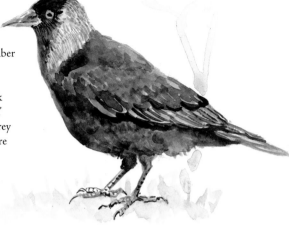

JACKDAW A highly intelligent member of the crow family, they are noisy and sociable and found around farms and churchyards. On the ground they walk with a swagger and make a loud 'chack' sound. They are identified by a pale grey patch on the back of the head. They are notorious for their habit of collecting bright objects.

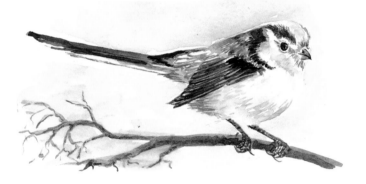

LONG-TAILED TIT These pretty tits live in woodlands and hedgerows. They can often be seen in noisy flocks when feeding. They roost communally and huddle together for warmth. Their plumage is black and white with a pinkish back and underparts. They feed mostly on insects but also peck lichen and green algae off trunks and branches. They make beautiful camouflaged nests covered in lichen and moss and lined with feathers.

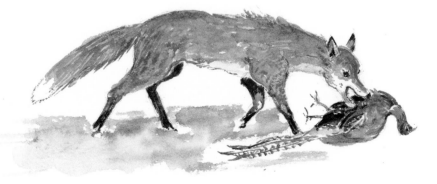

A hungry fox preys on birds and rabbits

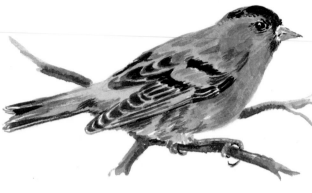

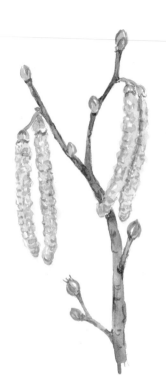

SISKIN (*above*) These colourful little birds are numerous and widespread. They are usually found in or around conifer forests feeding on cones of alder and birch. They look rather like greenfinches with their yellow wing bars and rump but have a black bib and forehead and are slimmer and smaller.

CATKINS (*left*) Also known as lamb's tails, these appear in January on hazel trees long before the leaves. They start as small greenish-brown drooping buds which gradually grow longer, turning into a cluster of suspended yellow flowers covered in pollen in mid-February which are dispersed by the wind.

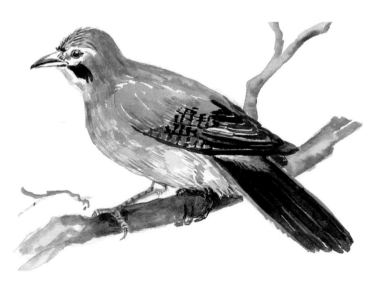

JAY These birds, which live in the woods, are more often heard than seen, as they make their familiar screeching noise. They are smartly coloured with buff-pink body plumage and white underparts and have black and white patterned wings with iridescent blue and white chequered feathers on the edge. They also have a distinctive black moustache. They store acorns in the autumn, hiding them in holes or under leaves. This could possibly be one way the oak woods spread.

STARLING IN WINTER PLUMAGE These common birds gather in big noisy flocks to roost. They settle on trees at dusk but can be seen at any time in their hundreds flying from treetop to treetop. They roost in trees or buildings. Their winter plumage is black with white flecks. They look black in flight. In summer their plumage is an iridescent blue/green.

A birch log covered in moss

A HERD OF FALLOW DEER I have suddenly come across a small herd of fallow deer like this, looming out of the mist on a winter's morning. Fallow are easily identified by the black stripe on their white tails. I have counted a herd of seventy-eight deer at one time.

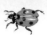

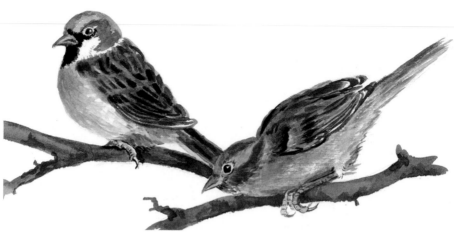

*Clockwise from above:*

HOUSE SPARROW These lively birds like to live
close to habitation, nesting under eaves and in holes in
the walls of houses and barns. They have two broods
between May and August. The eggs are white or grey,
speckled with black or brown. In autumn, flocks of
sparrows gather in harvest fields feeding on grain.

TREE SPARROW These are becoming very scarce. They
look similar to the house sparrow, with a chestnut cap and
white cheeks. They feed on seeds, insects, and spiders,
nesting in holes in old trees, farm buildings or in dense,
mature hedges.

DOG'S MERCURY These bright green flowers
carpet the woodlands in late February. Dog's Mercury is
poisonous with a nasty smell.

SWEET VIOLETS These are the first violets to be seen
in spring. They are dark purple with bright green leaves.
They appear in large clumps and are sweet smelling.

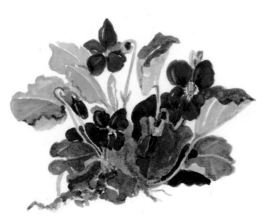

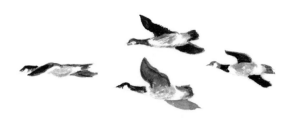

CANADA GEESE These originally came from North America but have established themselves here, living in large flocks over the last twenty years. They are identified by their black head and neck. They are found in water meadows by the rivers and smaller numbers on and near ponds and lakes.

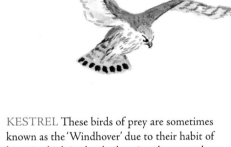

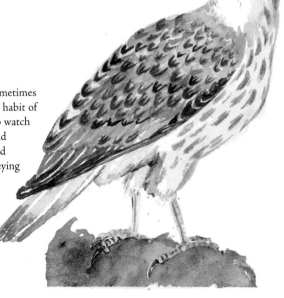

KESTREL These birds of prey are sometimes known as the 'Windhover' due to their habit of hovering high in the sky, keeping sharp watch out for any small rodents on the ground below. They are often seen on posts and wires near roads and motorways, surveying the verges. They will sweep down and grab the prey in their claws. They are identifiable by their pointed wings. They nest in holes in trees or abandoned crows' nests.

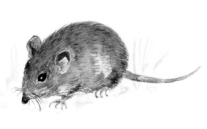 

BANK VOLE (*left*) These little rodents feed on green plants, hips, haws, etc. They make a grass nest under tree roots and about four young are reared between April and September. Apart from birds of prey they have many enemies, including weasels, cats, foxes, owls, and adders.

RED DEAD NETTLES (*right*) This prolific little plant is one of the earliest to flower and continues until autumn. It is found on the edge of cultivated fields.

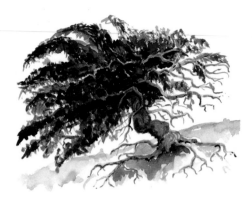

YEW Many superstitions surround this tree. It is said that their heavy, dark green foliage sheltered the first Christian missionaries to Britain before their churches were built, thus there are many ancient yews found in churchyards. Yew symbolises life and was sometimes scattered on graves. In medieval times, the long, straight, knot-free branches from tall trees were made into longbows, being flexible and strong. Some of the oldest wooden weapons and tools found were made of yew. Nowadays its multi-knotted and reddish coloured wood makes beautiful furniture.

The yew is native to Britain and some are believed to be 1,000 years old. They are found all over but mostly on the chalk downs of southern England. They do not grow very tall, 40-50 feet, but some have huge girths and wonderful gnarled trunks. They are often found on steep chalk inclines, their roots exposed, twining over the ground. Their dark foliage and interesting shapes make them good painting subjects.

Yew is highly poisonous. Wild animals seem to recognise this. However, clippings from the trees seem to be highly palatable to farm stock, with fatal results.

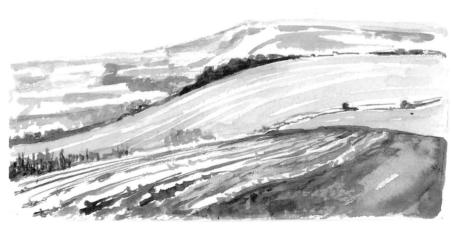

*A wintry view from Bignor Down looking towards Chanctonbury*

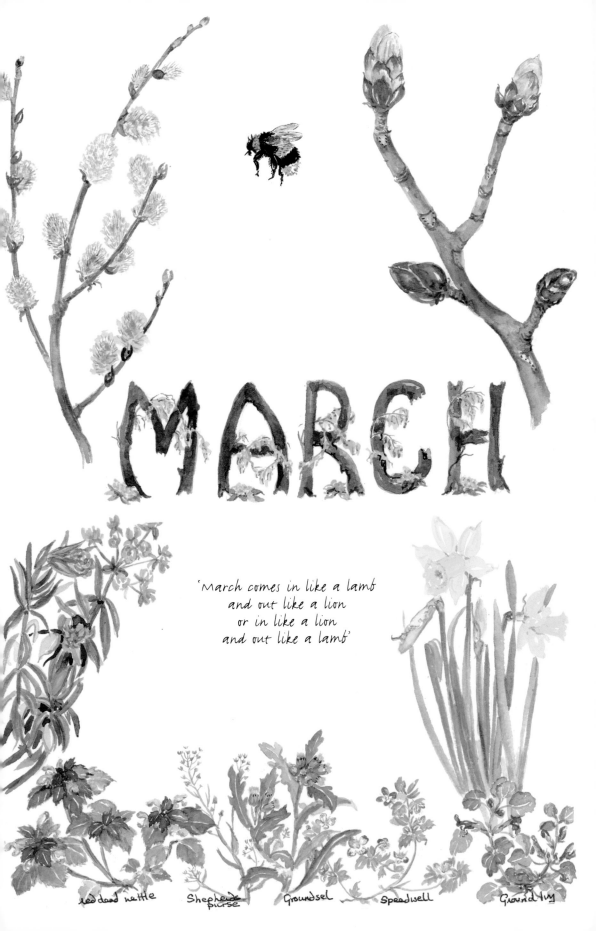

# MARCH

'March comes in like a lamb
and out like a lion
or in like a lion
and out like a lamb'

red dead nettle      Shepherds purse      Groundsel      Speedwell      Ground Ivy

MARCH is often a bleak month and the weather is unpredictable but there can be lovely bright sunny days which show promise of spring. The old adage 'March comes in like a lamb and out like a lion or in like a lion and out like a lamb' tells us how variable the weather can be. Birds begin to get active and noisy, staking out their territories and looking for mates. Early summer migrants begin to arrive.

IVY LEAVED TOADFLAX This is a creeping plant well adapted to live on dry walls.

BEE FLY (*above left*) These are seen in early spring on Bugle and Primroses. They have small orangey hairy bodies, and a long proboscis.

A VERY EARLY BUMBLE BEE (*above right*)

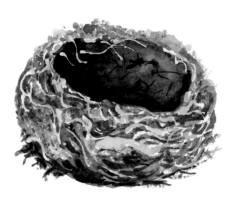

The winter months are a good time to look for old birds' nests when the hedges and trees are bare. This is probably an old blackbird's nest woven with moss and grass and lined with mud.

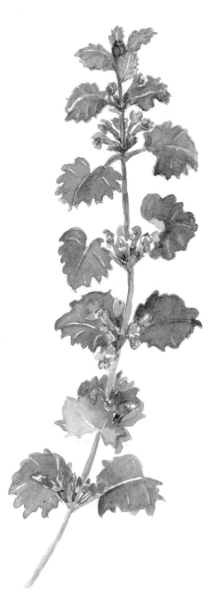

GROUND IVY This creeping plant is a member of the mint family. It is very common on grassy banks in March and April.

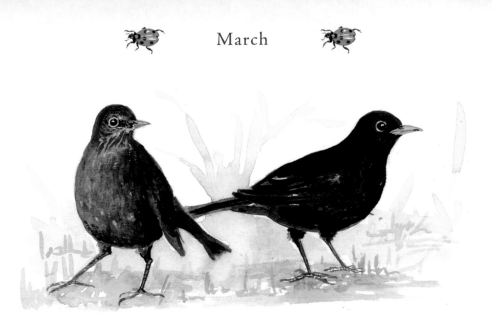

BLACKBIRD These are a member of the thrush family and are very common on farmland and in gardens. The male is black with a yellow eye ring and beak, and the females are dark brown. They are very active in the winter, hunting amongst the dead leaves for earthworms. They also eat berries and fallen fruit. They build a solid nest of grass and moss lined with mud. Their eggs are blue-green with brown freckles. They start their territorial singing in mid-November. Occasionally one sees a blackbird with a few white feathers.

PRIMROSE These lovely little flowers can appear much earlier in the year but by March they are abundant, carpeting the banks and hedgerows in their masses. The name comes from the Latin *prima rosa*, the first bloom of spring.

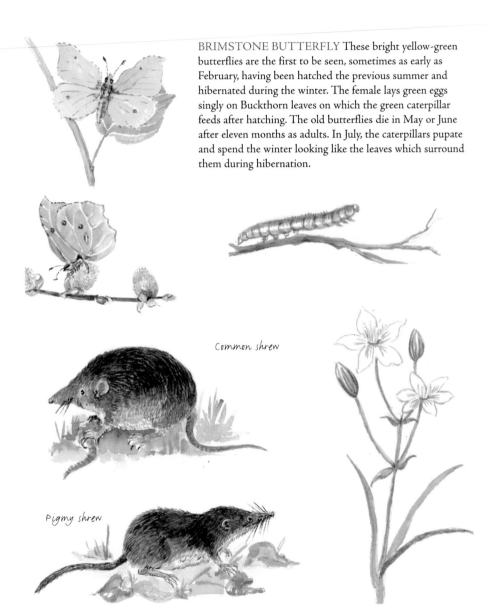

BRIMSTONE BUTTERFLY These bright yellow-green butterflies are the first to be seen, sometimes as early as February, having been hatched the previous summer and hibernated during the winter. The female lays green eggs singly on Buckthorn leaves on which the green caterpillar feeds after hatching. The old butterflies die in May or June after eleven months as adults. In July, the caterpillars pupate and spend the winter looking like the leaves which surround them during hibernation.

Common shrew

Pigmy shrew

SHREW (*above left*) These tiny, busy, little animals can be found anywhere in the undergrowth. They are active twenty-four hours a day, feeding on insects, spiders, worms, and small molluscs, consuming the equivalent of their bodyweight every day. They are aggressive and territorial, and have short lives as they die very quickly if they run out of food. They nest in a ball of woven grass under tree roots and stones in the long grass. Shrews possess scent glands which they leave as a trail to locate each other and mark out their territories. These glands make them taste nasty so they are only eaten by owls and foxes.

STAR OF BETHLEHEM (*above right*) These flowers can grow really tall. The six-petalled flowers are star-like, similar to Stitchwort but with a green stripe at the back of each petal, seen before they open at mid-morning. (They are sometimes called 'ten-o-clock lady'.)

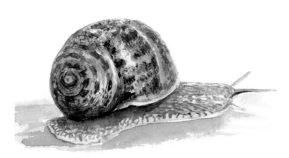

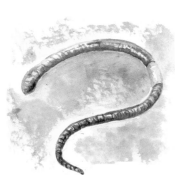

SNAIL (*above left*) These belong to the mollusc group – along with oysters, limpets, etc. Their shell is composed mostly from chalk and is their home, a hollow cone around a central column. Only the head and foot can be seen. The garden snail eats plants, decaying matter, and fungi. They are eaten by birds, particularly thrushes, which can be seen hammering them on stones to break their shells. Snails are nocturnal and hibernate in crevices and under logs and stones, emerging in spring to mate. They are hermaphrodites (bisexual), and can live for two years.

EARTHWORM (*above right*) These are eaten by birds, badgers, and hedgehogs, as well as moles. There are apparently three million living in every acre of grassland. Their segmented bodies burrow through the earth acting as ploughs, sifting and aerating the soil.

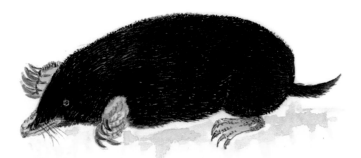

MOLE These little animals are well adapted to life underground, with a cylindrical body covered in short, thick, velvety fur that does not ruffle, thus enabling them to move backwards and forwards in their tunnels. They have small eyes and no external ears, just openings protected by a narrow ridge of skin. They eat insects, larvae, earthworms and frogs. Moles eat at least fifty earthworms a day which they often store in underground larders. They bite their heads off to prevent them escaping. The worm can grow a new head if the mole does not eat the body.

MOLEHILL The mole spends most of its life in its complex network of underground burrows and passages, only rarely coming to the surface. The molehills seen above ground are the only sign that moles are present.

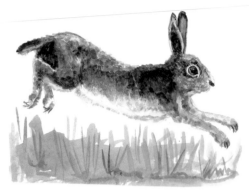 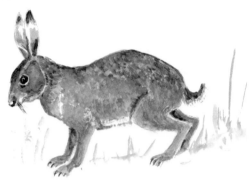

HARE These are distinguished from rabbits by their longer ears and large hind legs and are also a brighter colour. They are easier to see before the spring grass thickens. They live in open farmland in hollows called 'forms' in the grass or corn. They are fast runners and are seen playing or 'boxing' in March – thus the saying 'mad as a March Hare'.

*Clockwise from below left:*

CHICKWEED This is a low growing weed which flowers all the year round. It is a popular food for birds.

LEAST CINQUEFOIL This small plant is found in March in damp woodland.

VIOLET These are found in clumps close to the ground. Although they are usually dark purple, they can also be white or pink.

GREEN HELLEBORE This wild version of the garden plant is found in March woodlands in isolated patches.

 BUMBLE BEE There are sixteen varieties of these attractive bees, varying in size. Colours range from grey and buff to dark rust and black stripes. Most live in holes in banks, hollow trees, rocks, and walls. They depend on flowers for their food.

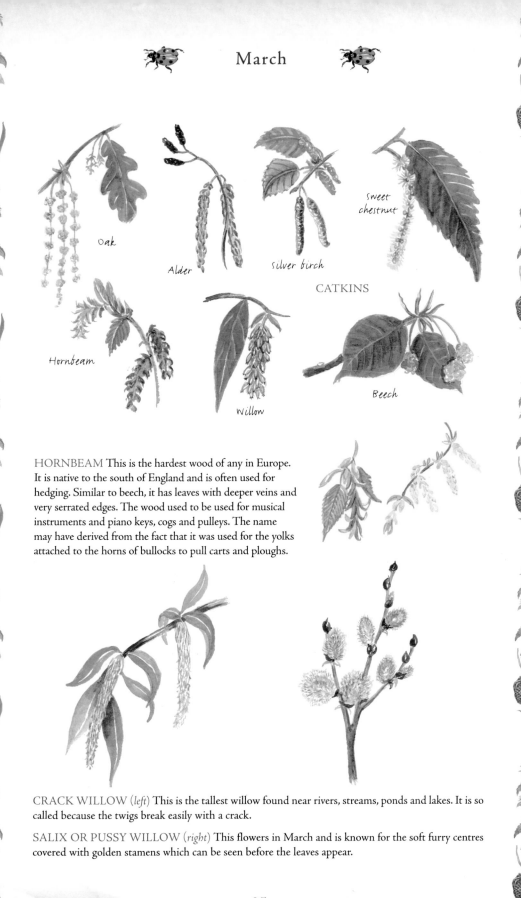

Oak

Alder

silver birch

sweet chestnut

CATKINS

Hornbeam

Willow

Beech

**HORNBEAM** This is the hardest wood of any in Europe. It is native to the south of England and is often used for hedging. Similar to beech, it has leaves with deeper veins and very serrated edges. The wood used to be used for musical instruments and piano keys, cogs and pulleys. The name may have derived from the fact that it was used for the yolks attached to the horns of bullocks to pull carts and ploughs.

**CRACK WILLOW** (*left*) This is the tallest willow found near rivers, streams, ponds and lakes. It is so called because the twigs break easily with a crack.

**SALIX OR PUSSY WILLOW** (*right*) This flowers in March and is known for the soft furry centres covered with golden stamens which can be seen before the leaves appear.

'One for sorrow,
Two for joy,
Three for a girl,
Four for a boy.
Five for silver,
Six for gold,
Seven for a secret that
has never been told'

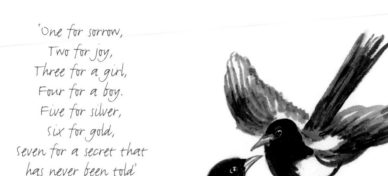

MAGPIE These are rather unpleasant birds which prey on smaller birds' eggs and nests. However, they are attractive to look at with their smart black and white markings. They are often seen in pairs or groups, and in folklore it was said to be unlucky to see one magpie. I was told to say 'Down Devil, down' and then count backwards, 7,6,5,4,3,2,1, to ward off bad luck if I saw one magpie on its own.

COAL TIT These little tits are fairly common, found in coniferous and deciduous woodland. It is identified by a white patch on the nape of its head, two white wing bars, and pale pinkish underparts.

BLACKTHORN This is the flower of the sloe or wild plum which appears in March before the leaves. It is supposed to be unlucky to bring it in the house but it bedecks the hedgerows with delicate little white flowers well into April. From a distance it looks like May blossom, the flower of the hawthorn which flowers in May. When the leaves appear the bushes are dense and make popular places for nesting birds, particularly thrushes, dunnocks, and blackbirds. The fruits can be made into sloe gin and in Ireland the stems were made into a shillelagh – a cudgel secured at the wrist by a leather strap. The stems are also made into walking sticks.

FROG These amphibians are greener and slimmer than toads with a smoother skin. They can change colour to match their surroundings. The males are smaller and have swollen pads on their thumbs. Although usually found near water, frogs are able to live on land and in the winter they hibernate in holes at the bottom of ponds or ditches. They spawn earlier than toads in March and April.

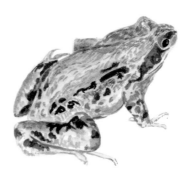

FROG SPAWN Frogs lay their spawn in large clumps.

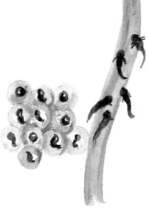

'Frogs in March
Frost in May'

TOAD These amphibians live in warm, moist, leafy places, blending with their surroundings. They hibernate under stones and logs in the winter months. Although they spend most of their time on land they go back to the ponds to breed in March and April. They take a lot of trouble choosing their breeding pond and can travel a mile or so, often getting squashed on the roads, but return to the same pond year after year. They secrete a poisonous substance to ward off predators.

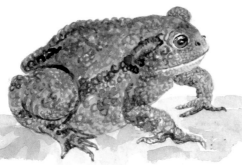

TOAD SPAWN Toads' eggs are laid in strings, often around reeds.

FALLOW DEER (*right*) These were introduced to this country by the Romans. They are dark grey-brown in the winter and a dappled light brown in spring and summer, and their backs and flanks are covered in white spots. They are distinguishable from roe deer, being bigger, having longer tails which are white at the sides with a black stripe down the middle, and by moving around in much bigger herds.

CHIFFCHAFF (*below*) This bird is the earliest summer visitor, which arrives in March or early April. It is the first of the small warblers to arrive and the last to leave. It is a pretty, active little bird, named after its quick clear notes. It lives in woods and hedgerows, feeding on insects which it captures in flight.

SPEEDWELL OR BIRD'S EYE (*opposite*) A member of the Veronica family, this flower is bright blue with a white eye. There are many different varieties found in woodlands, on banks and verges, and in arable fields. The name 'Speedwell' may come from 'speed you well' or speedwell, meaning farewell, due to the fact that the petals fall off when picked so the flower is quickly gone.

DAISY (*right*) This little flower is found in meadows all through the spring, summer, and autumn. In wet dull weather and at night the petals close. The petals are pink on the outside. The stems and leaves are unpalatable to eat and are left alone by cattle, sheep, horses, and wild animals. For centuries it was used as a herbal remedy for many ailments and wounds. The name is derived from the Anglo-Saxon *daeges eage* – Day's Eye.

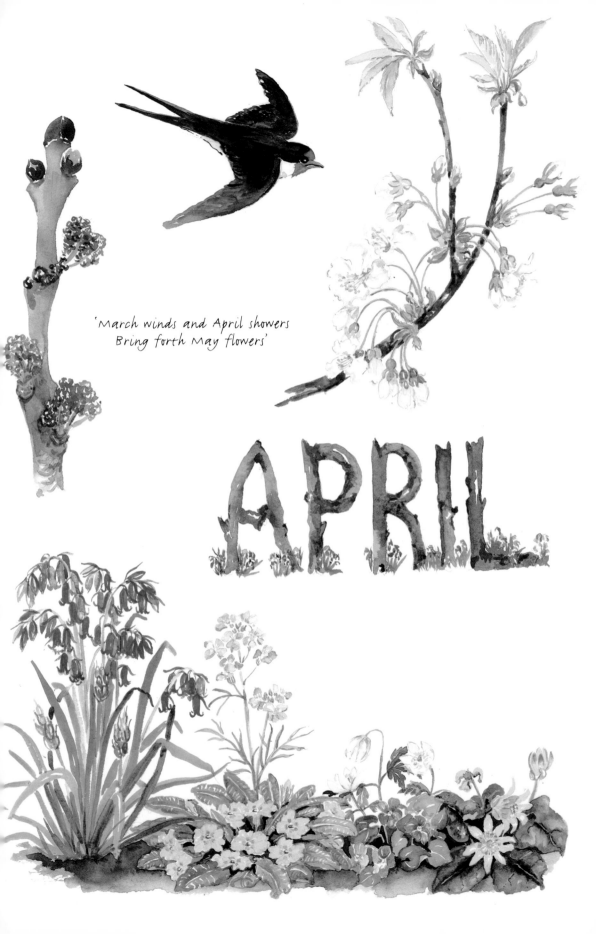

'March winds and April showers
Bring forth May flowers'

APRIL

APRIL is the second month of the Roman calendar and the fourth of ours. The name implies 'opening' derived from the Latin *aperire* – the opening of flowers and leaves.

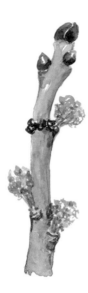

ASH (*left*) There is an old saying 'If the oak comes out before the ash the summer will have a regular splash. If the ash comes out before the oak the summer will be a soak.' This implies that if the ash, which is one of the last trees to come into leaf, comes out early, we will be in for a wet summer. It has dark pink-purple flowers in April, sprouting each side of the black, spear-like leaf-buds.

WILD CHERRY OR GEAN (*right*) In late April these lovely trees are covered in white blossom just before the leaves come out. The blossom only lasts a week. In autumn the leaves turn orange and red and drop, leaving a colourful carpet on the ground.

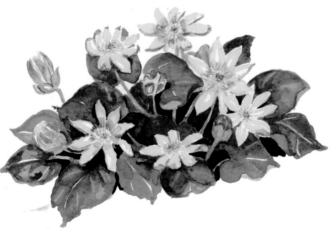

CELANDINE (*above*) The roadsides and banks are covered in these shiny yellow flowers with attractively marked blotchy leaves. They only flower when the sun is out. In dull weather and in the evening they close their petals.

ARCHANGEL (*right*) These yellow, nettle-like flowers are found on banks and in hedgerows in April and May. It is also known as 'Weasel Snout.'

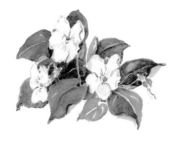 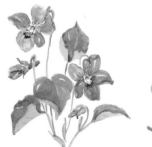 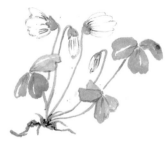

*Clockwise from above left:*

WHITE VIOLET These can be found on banks and verges of local lanes as well as in woodland glades. They are quite scarce and hard to find.

DOG VIOLET These are found in woodlands and on verges and banks and areas of old turf on the downs.

WOOD SORREL This delicate little flower is rather like a wood anemone and grows in damp woods. It has three heart-shaped leaflets which close when the sun strikes them so they sink onto their stem like a three-sided pyramid. Only when in the shade do they open fully.

GOLDEN SAXIFRAGE This is found in April, carpeting the ground and mingling with wood anemones, primroses, lady's mantle, and violets in damp woodlands. It has yellow-green bracts or sepals instead of petals.

HOUNDSTONGUE (*above*) These ferns are found in damp places in woods and beside streams.

CLEAVERS OR GOOSEGRASS (*right*) The stem, leaves, and fruits of this plant have hooked hairs which catch in clothing and cleave to passers by. They can grow very tall on scrub or wasteland. It used to be fed to goslings, thus the name goosegrass.

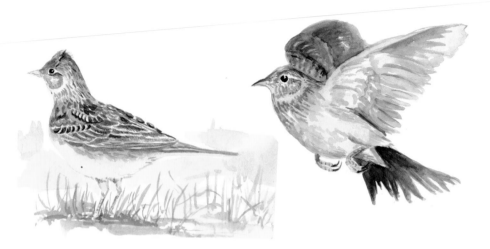

SKYLARK Although it is said that these are on the decline I see numerous larks soaring over the spring and summer fields, singing heartily. Their numbers swell in the winter with migrants from Scandinavia. Larks nest on the ground in a cup of grass.

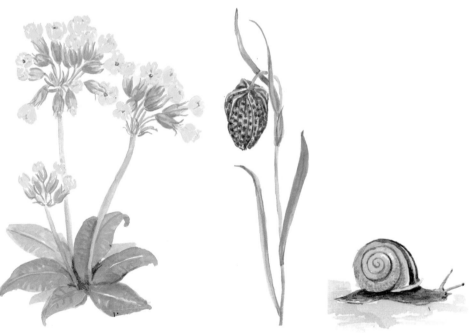

COWSLIP (*left*) These were common all over the downs but due to the extensive cultivation they are now confined to grassy banks and areas of uncultivated turf.

SNAKESHEAD FRITILLARY (*middle*) These exotic looking flowers grow in damp areas, water meadows, and beside ponds and streams. They are quite rare, flowering for a short time in April. They are mostly pink but can be white.

WHITE-LIPPED BANDED SNAIL (*right*) This snail is common in woods and hedgrows. Its colours vary from yellow with darker yellow bands to yellow with brown bands.

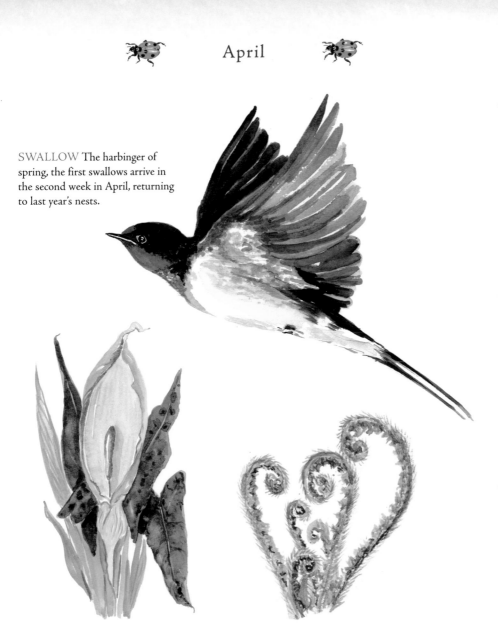

SWALLOW The harbinger of spring, the first swallows arrive in the second week in April, returning to last year's nests.

CUCKOO PINT, ARUM LILY OR LORDS AND LADIES (*above left*) This is an exotic looking common wild plant which lives on banks and in fields and woods. It has tuberous roots, large spade-shaped leaves, often with spots, and a tall pointed sheath which surrounds a fleshy stem and a purple-red flower. This gives off an unpleasant smell which attracts insects that then get trapped in the downward pointing hairs in the sheath, thus pollinating the flower. The red berries which appear in July are very poisonous.

MALE FERN (*above right*) This appears in late spring.

silver washed fritillary caterpillar

HORSE CHESTNUT This handsome tree thrives in open fields and parks. Not indigenous to this country, it has adapted well and is familiar sight in the countryside. It is often found near habitation and villages. In early spring the large sticky buds burst into leaves and in May they have large erect flower bracts, known as candles. The fertilised flowers become conkers in autumn.

BEECH (*above*) The first sign of beech leaves appearing.

WHITEBEAM (*right*) This tree has lovely pale green leaves bursting out from buds and white blossom in May.

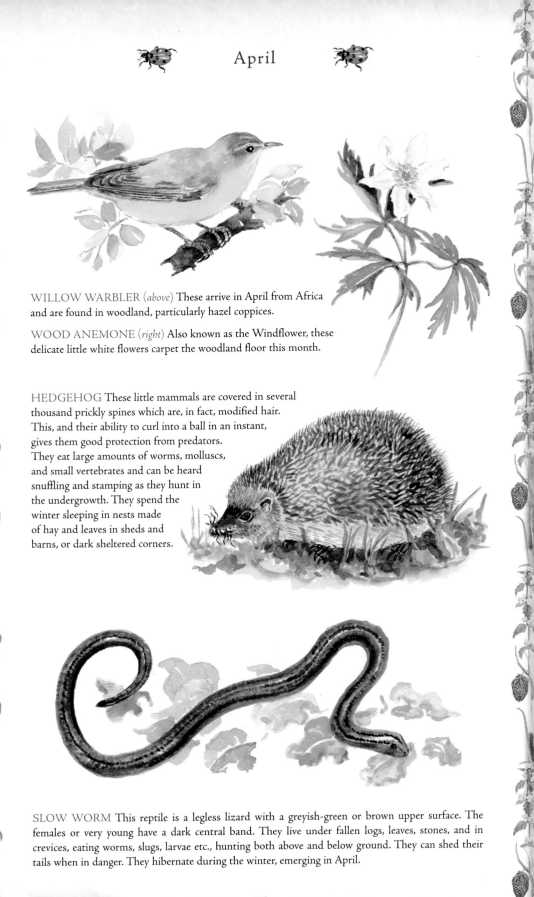

# April

WILLOW WARBLER (*above*) These arrive in April from Africa and are found in woodland, particularly hazel coppices.

WOOD ANEMONE (*right*) Also known as the Windflower, these delicate little white flowers carpet the woodland floor this month.

HEDGEHOG These little mammals are covered in several thousand prickly spines which are, in fact, modified hair. This, and their ability to curl into a ball in an instant, gives them good protection from predators. They eat large amounts of worms, molluscs, and small vertebrates and can be heard snuffling and stamping as they hunt in the undergrowth. They spend the winter sleeping in nests made of hay and leaves in sheds and barns, or dark sheltered corners.

SLOW WORM This reptile is a legless lizard with a greyish-green or brown upper surface. The females or very young have a dark central band. They live under fallen logs, leaves, stones, and in crevices, eating worms, slugs, larvae etc., hunting both above and below ground. They can shed their tails when in danger. They hibernate during the winter, emerging in April.

STITCHWORT These small star-like flowers on long thin stalks are very prolific on the banks and verges. It can also be called 'Adder's Meat' and 'Satin Flower'.

LADYBIRD This beetle is usually red but can also be yellow. They eat aphids and other bugs. The most common is the seven spot ladybird.

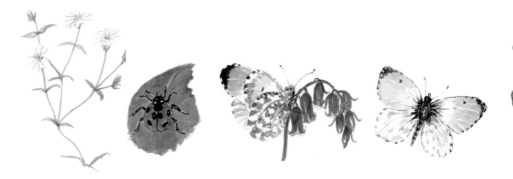

ORANGE TIP BUTTERFLY These are plentiful in April. Only the male has orange tips to its wings. The underwings are marbled. The larvae feed on cuckoo flower (Lady's Mantle).

WATER VOLE These are not often seen but are found by rivers, streams, ponds, and lakes. They live in holes and burrows just below the water line. These short-sighted vegetarians can easily be confused with water rats.

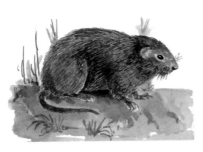 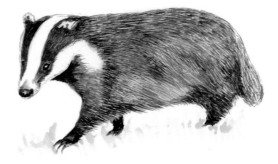

BADGER These animals are very common in the countryside nowadays. When I was young it was a great excitement to see one at night, now it is not unusual to see them in the woods in broad daylight, and they visit village gardens to eat eggs, fruit, and vegetables. They live in setts which are large complexes of holes and tunnels. Small pits can be found nearby for their droppings and very obvious tracks can be seen between holes and scratch marks, on nearby trees, where they clean their large claws. Their young are born in February but are not seen outside until April. They air their bedding, bringing it outside into the sun and taking it back into the sett again. As well as fruit and berries they eat worms, frogs, snails, and mice, and will dig up wasp and bee nests in the ground for grubs and honey. The badger used to be called a 'brock' or 'brawson'. The female is known as a sow and the male a boar. This may be because they grunt rather like pigs.

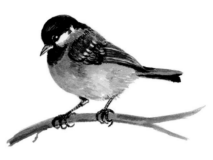

MARSH TIT These are very similar to the Willow Tit but without the white wing panel. They are found in woodland often near ponds and streams.

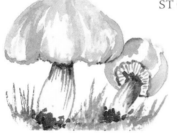

ST GEORGE'S MUSHROOM (*left*) These are very early mushrooms found around 24 April (St George's Day).

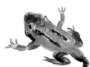

Young toad          Young frog

Forget-me-not

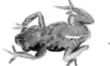

scarlet
pimpernel

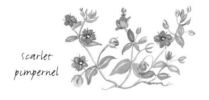

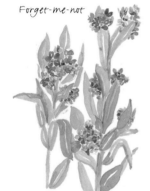

FORGET-ME-NOT There are ten different species of this flower. It is one of the earliest spring flowers found on banks and in fields.

SCARLET PIMPERNEL AND CHARLOCK These little plants grow as weeds at the edge of cultivated fields, flowering almost all the year round.

Bluebell woods

Charlock

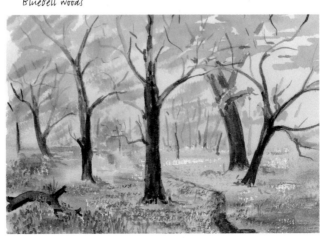

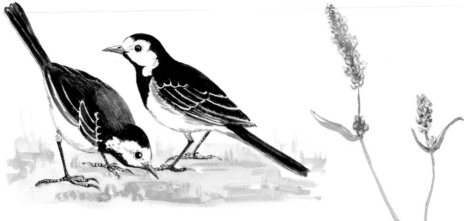

PIED WAGTAIL (*above*) These attractive little birds are usually found near grazing animals, looking for flies and insects. They strut around with their long tails bobbing up and down. The male has a blacker back and a larger bib than the female.

REDSHANK (*right*) This prolific annual weed grows almost everywhere on farmland. It can grow very high and has a red stalk and black blotches on its leaves.

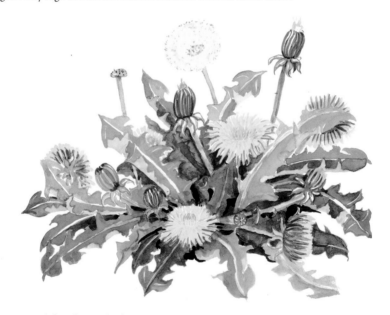

DANDELION This plant is also known as 'The Schoolboy's Clock'. In French it is called 'Pis-en-lit' due to its diuretic properties and 'Dent de Lion' due to its deeply serrated leaves. They vary in size and height according to where they grow, adapting themselves to suit their surroundings. Where there is plenty of light and the grass is short the dandelion grows close to the ground, forming a rosette with its leaves. In the long grass and on banks and verges it grows tall and the leaves grow upright. It has a long growing season from March until late autumn. Like the daisy it opens in bright sunlight and closes in rain or dull weather. Its round seed heads are attached to small parachutes which disperse in the wind. Children blow on them to tell the time. I find the dandelion interesting to paint in all its stages.

# MAY

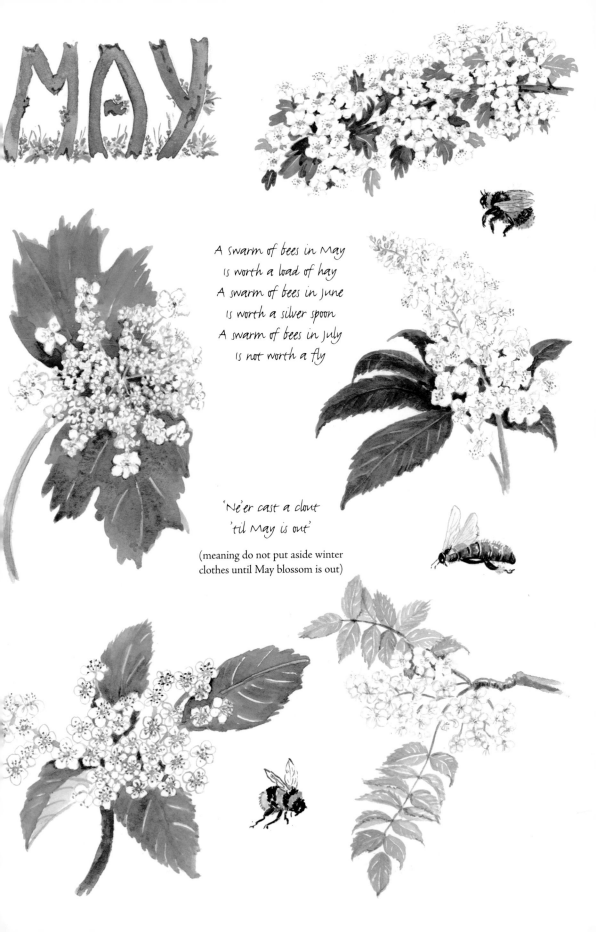

A swarm of bees in May
is worth a load of hay
A swarm of bees in June
is worth a silver spoon
A swarm of bees in July
is not worth a fly

'Ne'er cast a clout
'til May is out'

(meaning do not put aside winter
clothes until May blossom is out)

MAY is the fifth month of the year but the third of the old Roman calendar. The name could have come from the goddess, Maia and been given in her honour. May Day has been celebrated for many centuries. May is a month of white blossom, trees in flower, heavy scents, twittering birds mating and nesting, swallows wheeling and swooping, and flowers, bees, and butterflies.

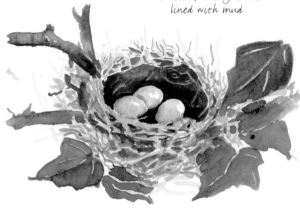

The nest of a song thrush lined with mud

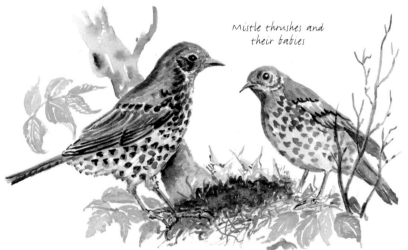

Mistle thrushes and their babies

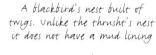

A long-tailed tit's nest in a gorse bush.

A blackbird's nest built of twigs. Unlike the thrusht's nest it does not have a mud lining

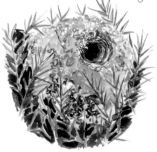

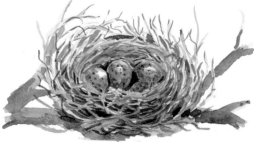

# FLOWERS FOUND IN THE WOODS, BANKS AND MEADOWS IN MAY

RANSOMS OR WILD GARLIC These are found abundantly in the damp woodland. The leaves may be eaten in salads. The plant was used by old herbalists for treating asthma and lung ailments. 'Eat leeks in Lide (March) and Ransoms in May and all the year after the physicians may play.'

STITCHWORT Named because it was thought to cure the stitch in the side. A straggly plant found on banks and hedgerows, it is similar to the Star of Bethlehem.

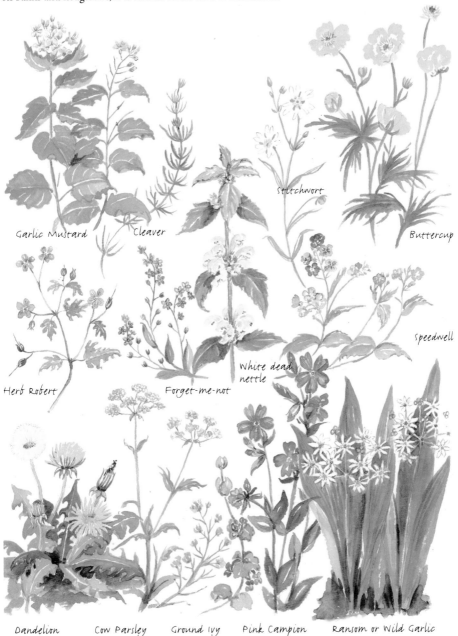

Garlic Mustard    Cleaver

Stitchwort

Buttercup

Herb Robert    Forget-me-not

White dead nettle

Speedwell

Dandelion    Cow Parsley    Ground Ivy    Pink Campion    Ransom or Wild Garlic

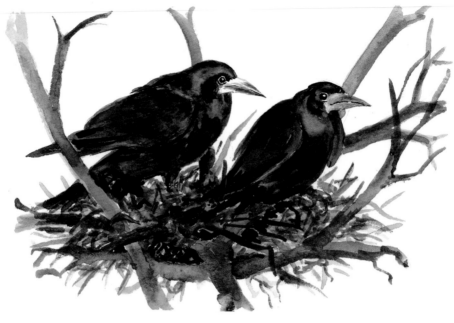

A ROOKERY A community of rooks nest close together on the top of tall trees. They are gregarious birds who quarrel and chatter among themselves. Their nests are cleverly entwined and woven into the top-most branches of high trees so firmly that they can be used year after year. When feeding their young they collect food in a pouch below their beaks, bringing it back and feeding small portions to them.

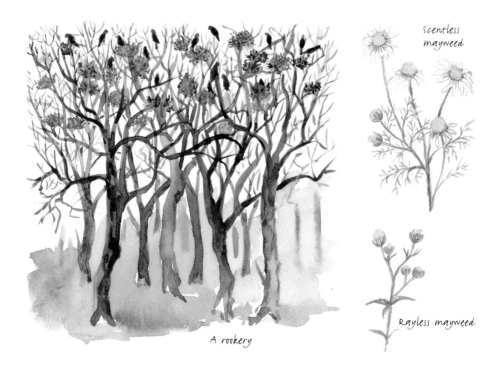

scentless
mayweed

A rookery

Rayless mayweed

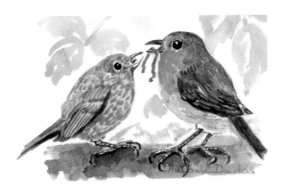

A ROBIN FEEDING ITS BABY (*above*) Baby robins are brown with speckles.

BROOM (*right*) Not to be confused with gorse it has no prickles. It is a primitive version of the garden variety, usually found on commons and sandy soil. It is named thus because it was often used to make brooms. It was also used for medicinal purposes. It is slightly poisonous and in olden days was given to sheep to ward off foot-rot. Apparently the shepherds would get drunk on the potion!

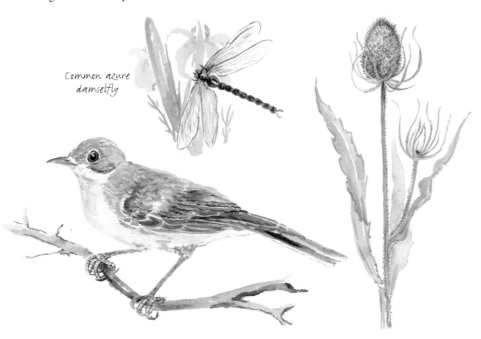

Common azure damselfly

WHITETHROAT (*above*) This warbler is a summer visitor found in scrubland and wild hedgerows from May to September. They overwinter in Africa.

TEASEL IN SUMMER (*right*) This plant can grow to 6 feet. It has prickly stems and flowerheads, surrounded by narrow leaves. It is attractive to goldfinches in autumn. The teasel can be used to raise the nap on velour or cashmere.

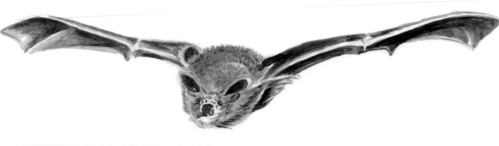

PIPISTRELLE OR COMMON BAT If you come across a bat, the chances are it will be a pipistrelle – the smallest and most common of the British bats. They are never seen during the day, living in barns and houses where they get in under the tile-hanging or eaves, often living in attics. They hibernate in the winter, coming out at dusk in spring when the weather is warm. They eat insects, especially flies.

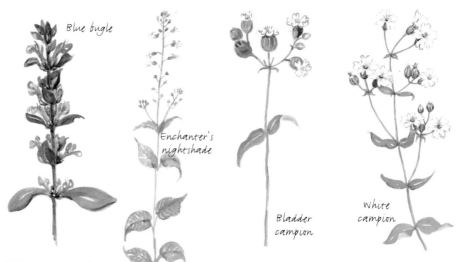

Blue bugle

Enchanter's nightshade

Bladder campion

White campion

BLUE BUGLE Often used in old herbal remedies.

BLADDER CAMPION This is so-called by the sepals which form a greenish calyx with dark veins resembling a bladder.

YELLOWHAMMER (left) These birds are familiar on farmland and in the hedgerows. The male is brighter and sings 'a little bit of bread and no cheese' in spring. It is a member of the bunting family and feeds on seeds and insects and can be seen in flocks after harvest.

Mottled umber moth caterpillar on an oak leaf

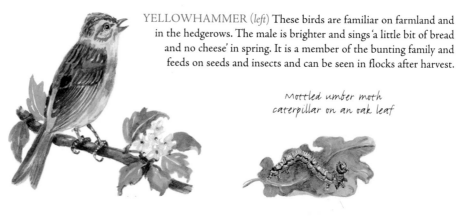

ADDER This is easily identified by the V-shape on the back of its head and a black zigzag all along its back. They can be seen basking in the sun in early summer. It is shy and avoids humans, only biting in self-defence. Its bite is poisonous and can kill a small dog. If bitten, hospital treatment is needed. I have always thought that adders preferred sandy soil but I have come across quite a few on the downs. In winter they hibernate in holes in the ground, emerging in spring on a sunny day. The female gives birth to between 5 and 20 young.

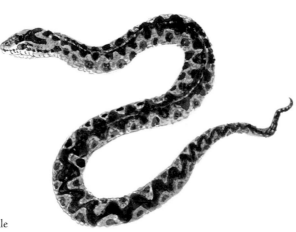

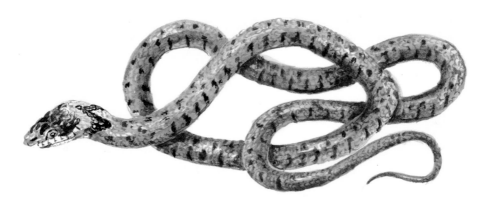

GRASS SNAKE These are brownish or greyish green with a distinguishing yellow collar and dark blotches along its body and a pale underside. It is longer than an adder, varying from 2-3 feet. It is often found near water and lays its eggs in mounds of decaying leaves or compost. Both these snakes are shy and scurry off if disturbed. When investigating a rustle in the undergrowth I have often seen a rapidly disappearing tail.

Grass snake babies emerging from eggs

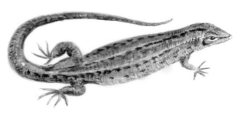

COMMON LIZARD These are very shy but can be seen on a sunny summer day when they come out to sunbathe, preferring sandy soil. They feed on insects, grasshoppers, and spiders.

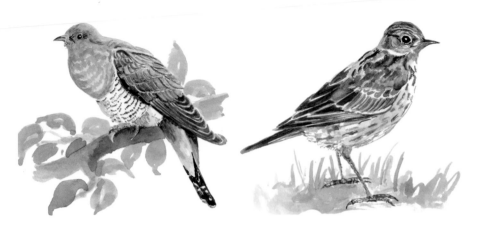

CUCKOO (*left*) These birds used to be widespread, heralding summer with their distinctive call. However, I only heard a couple last year so they are becoming scarce. They are shy birds and hard to spot, arriving from Africa in April. It is only the male that makes the 'cuckoo call', the female makes a bubbling sound.

MEADOW PIPIT (*right*) This bird is found in open grassland and makes a 'pseat, pseat' call. Their nests are often a host for cuckoos who lay their eggs in them. The young cuckoo throws out the pipit chicks and the poor little mother ends up feeding a great big demanding cuckoo chick!

'Turn your money when you hear the cuckoo and you'll have money in your purse 'til he come again'

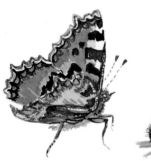

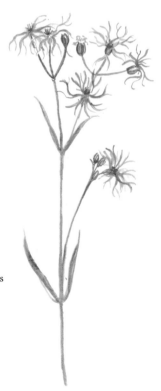

*Clockwise from left:*

TORTOISESHELL BUTTERFLY One of the earliest butterflies seen in summer. There are two varieties – the small and the large. Adults feed on nectar of autumn flowers before hibernating.

TORTOISESHELL CATERPILLAR These caterpillars feed on nettles.

RAGGED ROBIN This little flower is becoming rather scarce. It is found in damp woods.

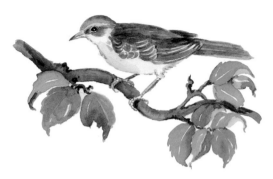

NIGHTINGALE Sadly these birds are getting very rare. They arrive from Africa in mid April and due to their plain brownish plumage are very hard to see in the dense undergrowth where they live. They make a wonderful sound on a summer's evening (they do sing during the day too) but only sing for a duration of six weeks during early summer.

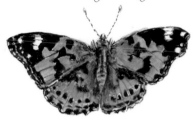

Painted lady butterfly

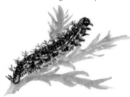

Painted lady caterpillar

Common twayblade

PAINTED LADY This butterfly arrives in Spring from North Africa. It rests with its wings open so can be easily identified. It is found in flowery meadows enjoying thistles, mallow and bugle.

PAINTED LADY CATERPILLAR The butterfly lays her eggs on thistles.

ELDER This is the only tree that rabbits find distasteful so it is often abundant around rabbit warrens, woods and hedges. It makes a good roosting place for birds, especially starlings and pigeons. Birds love the berries and help spread the seeds. It gets its name from the Saxon word 'hollow tree' as the stems are filled with pith which used to be hollowed out to make pipes and whistles.

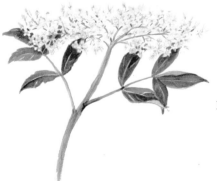

ELDERFLOWER In June the flowers have a heavy scent and can be used to make cordial or wine.

ELDERFLOWER CORDIAL
Infuse 40-50 elderflower heads in 3 pints boiling water
2 sliced lemons
4lb sugar
$2\frac{1}{2}$oz citric acid
Soak for three to four days, strain and bottle

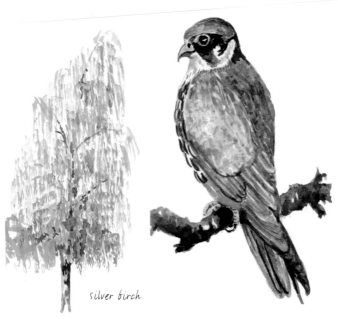

silver birch

HOBBY This bird arrives from Africa in May and stays for five months. They are identified by the rust red under the tail, chequered underwings and black moustache. They feed on young swifts, swallows, dragonflies and insects which they catch on the wing.

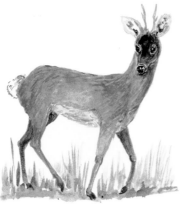

ROE DEER (*left*) These are smaller than fallow deer and with white powder puff-like tails. They are chestnut red in summer and dark brown in winter. They are indigenous to this country and were hunted in the royal parks and New Forest throughout the ages. They rut (mate) in July and August and the fawns are born in April-June.

A ROE DEER WITH HER NEWBORN FAWN (*below left*) This is a very unusual sight, and one I have been lucky enough to come across. The mother ran off but stood a short distance away, watching as I went by.

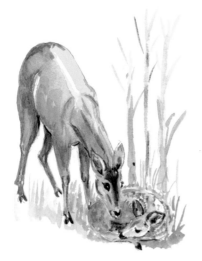

Early purple orchid

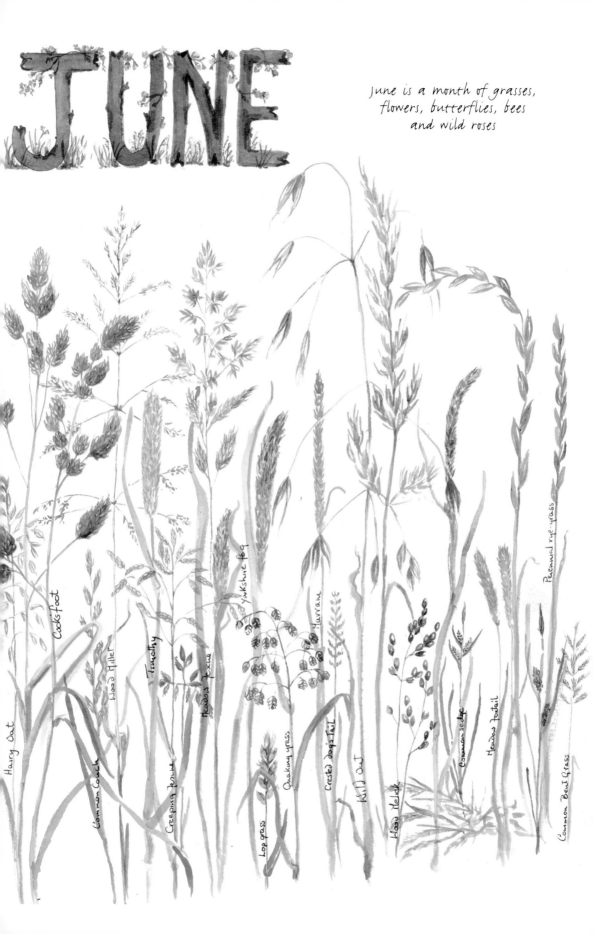

# JUNE

June is a month of grasses,
flowers, butterflies, bees
and wild roses

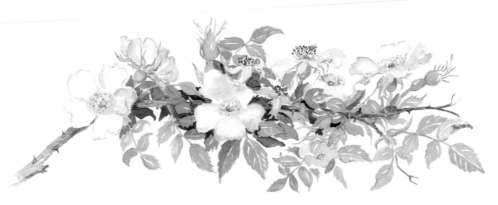

BRIAR OR DOG ROSE These are to me a sign that summer has arrived. They appear in the last week in May and ramble through the hedgerows, with their thin branches laden with pale pink flowers, until the end of June. Their fruits are the red rose-hips seen in the autumn.

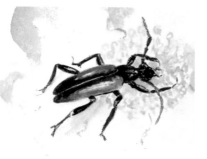

Honeysuckle

LONGHORN BEETLE These beetles live and breed in dead wood but feed on the nectar of wild roses.

WHITE BRYONY This trailing climbing plant (belonging to the cucumber family) coils high up the hedgerows. It has dull, hairy lobed leaves and long tendrils which change direction in the middle. Small yellow-green flowers become poisonous berries in the autumn.

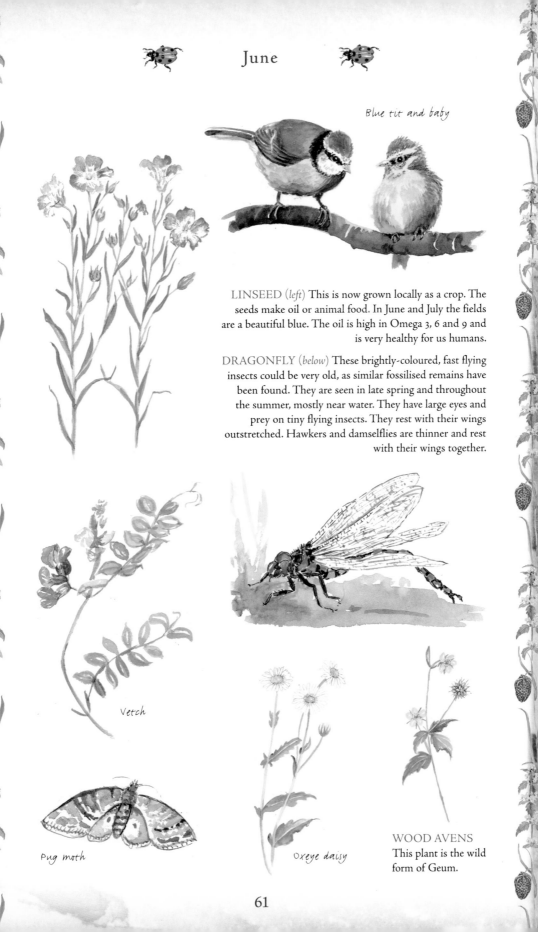

# June

Blue tit and baby

LINSEED (*left*) This is now grown locally as a crop. The seeds make oil or animal food. In June and July the fields are a beautiful blue. The oil is high in Omega 3, 6 and 9 and is very healthy for us humans.

DRAGONFLY (*below*) These brightly-coloured, fast flying insects could be very old, as similar fossilised remains have been found. They are seen in late spring and throughout the summer, mostly near water. They have large eyes and prey on tiny flying insects. They rest with their wings outstretched. Hawkers and damselflies are thinner and rest with their wings together.

Vetch

Pug moth

Oxeye daisy

WOOD AVENS
This plant is the wild form of Geum.

CUCKOO These extraordinary birds are declining in numbers. It is not known if this is due to the lack of suitable hosts here or the conditions in Africa. Some of the moth larvae that they feed on are in serious decline and cuckoos need to find food as soon as they arrive.

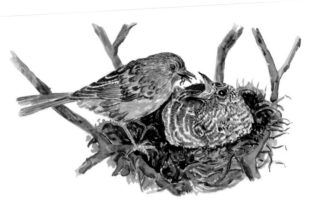

CREEPING CINQUEFOIL OR WILD POTENTILLA This is a herb with long runners like strawberries. It is widespread on verges. In the Middle Ages it was hung over doors to repel witches.

MILLIPEDE These harmless invertebrates eat decaying plants. They have two pairs of legs per body segment.

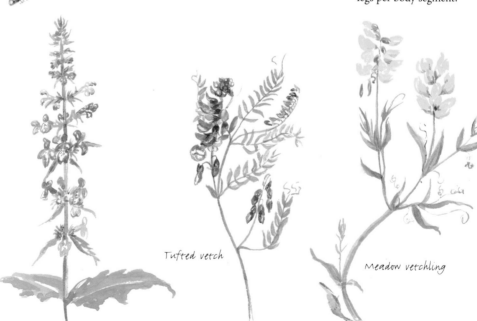

Tufted vetch

Meadow vetchling

WOUNDWORT The soft hairy leaves of the woundwort plant were used to treat wounds.

VETCHES These are members of the pea family, bearing long pods and tendrils for clinging to neighbouring plants.

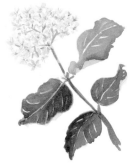

BUCKTHORN (*left*) This is a common shrub found on the Downs. Spines on its twigs discourage animals from eating its leaves. The flowers are borne on ridged spurs resembling a roebuck's antlers – thus 'bucks' horns'. It flowers in May and June and has blackberries in autumn.

*starling in summer plumage*

*small blue butterfly*

DUKE OF BURGUNDY FRITILLARY (*above*) This butterfly is not a true fritillary. It lives in woodland laying its eggs on cowslips and primroses. The pupa hatches in May. It is quite rare.

VIPER'S BUGLOSS (*above right*) This is a chalk-loving plant found extensively on the Downs. It can also be found on sandy soil near the sea.

*Ash in summer*

LADYBIRD These aphid eating beetles emerge from hibernation in March.

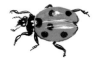

**LAPWING OR PEEWIT** (*left*)
These birds used to be seen in flocks on the Downs. However, now they are very scarce here. They are very handsome with long spiky head feathers and lovely iridescent green/black feathers on their backs. Their cry sounds like 'pee-wit', thus their name.

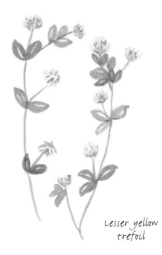

Lesser yellow trefoil

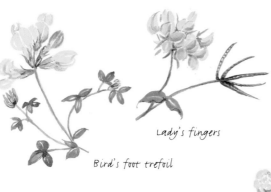

Lady's fingers

Bird's foot trefoil

**BIRD'S FOOT TREFOIL** (*above*) This plant likes chalk. It gets its name from the seed-head which is a thin curved pod looking like a bird's foot. It is also called 'Bacon and Eggs'.

**BUTTERCUP** (*right*) These shiny, bright yellow flowers that cover the meadows in summer are poisonous and are not eaten by animals.

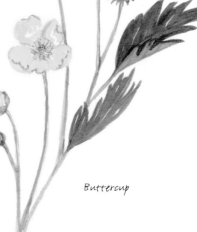

Buttercup

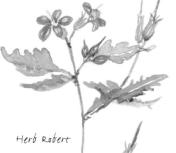

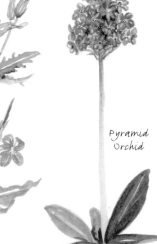

Herb Robert

Pyramid Orchid

I found this beautiful little nest on the ground where it had fallen out of a tree. It is made of woven moss, lichen, sheep wool, horsehair, and some red carpet! It was probably made by a goldfinch.

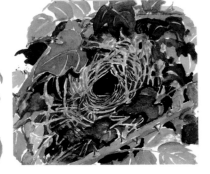

A wren's nest, well hidden amongst brambles and ivy leaves.

HERB ROBERT (*above left*) This little flower is found in woodland clearings, banks, and verges. It has dainty little flowers and geranium-like leaves which turn red.

PYRAMID ORCHID (*above right*) This is found on chalky downland grass.

SUMMER OAK (*below middle*) The Oak is England's traditional tree and they are very prolific. Many were lost in the Great Storm of 1987.

SPOTTED ORCHID (*below right*) These are common and found in woods and on verges and banks.

Poplar tree

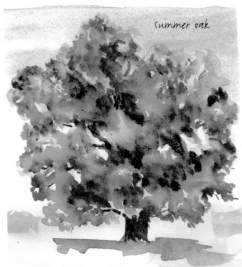

Summer oak

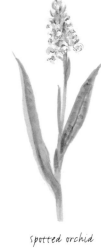

Spotted orchid

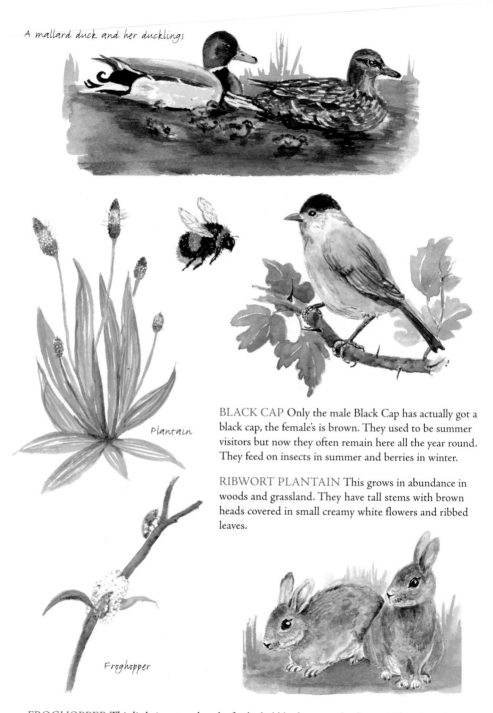

A mallard duck and her ducklings

Plantain

Froghopper

BLACK CAP Only the male Black Cap has actually got a black cap, the female's is brown. They used to be summer visitors but now they often remain here all the year round. They feed on insects in summer and berries in winter.

RIBWORT PLANTAIN This grows in abundance in woods and grassland. They have tall stems with brown heads covered in small creamy white flowers and ribbed leaves.

FROGHOPPER This little insect makes the frothy bubbles known as 'cuckoo spit' found on the leaves and stems of many plants. As soon as the young larvae or nymphs appear they expel air through a sticky secretion in their bodies and surround themselves with froth while they suck the sap. Two days later it is mature, becoming an insect with wings and powerful hind legs which it uses to make huge leaps. It is found when the cuckoo is here in summer.

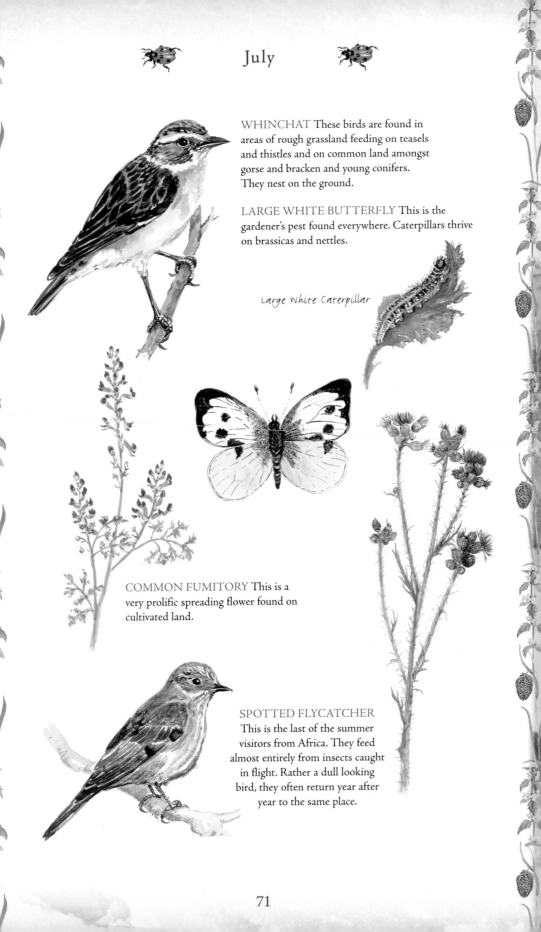

# July

WHINCHAT These birds are found in areas of rough grassland feeding on teasels and thistles and on common land amongst gorse and bracken and young conifers. They nest on the ground.

LARGE WHITE BUTTERFLY This is the gardener's pest found everywhere. Caterpillars thrive on brassicas and nettles.

Large White Caterpillar

COMMON FUMITORY This is a very prolific spreading flower found on cultivated land.

SPOTTED FLYCATCHER This is the last of the summer visitors from Africa. They feed almost entirely from insects caught in flight. Rather a dull looking bird, they often return year after year to the same place.

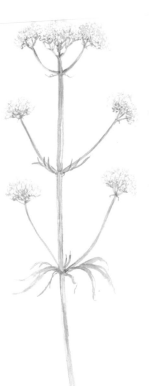

COMMON VALERIAN This is a herb found in rough grassland often beside streams or water. It can grow very tall.

TOOTHWORT This is a parasitic plant found at the base of hazel bushes in woods and hedgerows and quite rare. Herbalists used it as a cure for toothache.

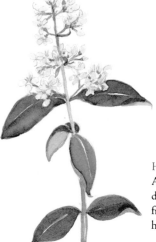

HUMMINGBIRD MOTH A summer visitor, this is a busy day-flying moth which darts from flower to flower making a humming-noise.

Privet Flower

Small White Butterfly

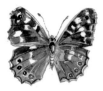

CARPET MOTH This is a common night-flying moth found in fields and gardens.

SPECKLED WOOD BUTTERFLY These are found extensively in woods, blending into their surroundings in the dappled sunlight. The larvae feed on grasses. It is small and green and hard to see.

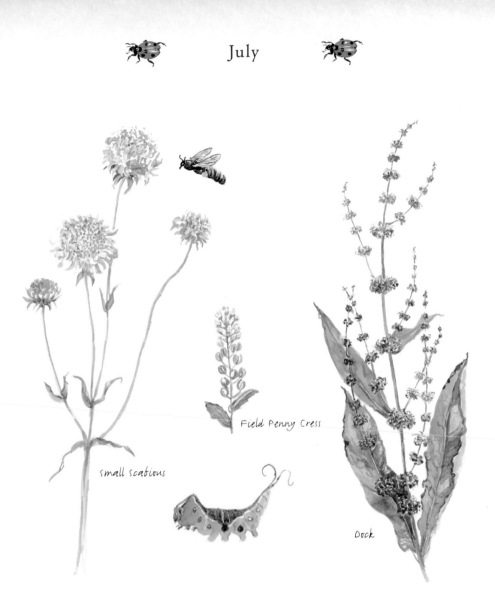

Field Penny Cress

small scabious

Dock

PUSS MOTH CATERPILLAR (*above middle*) These are found on willow and poplar trees.

SMALL SCABIOUS (*above left*) These are found everywhere on chalk grassland during this month. The Field Scabious looks the same but is taller.

DOCK (*above*) These prolific weeds have very long tap roots and are very hard to eliminate. The leaves are large and at first green but they turn orange and then red. These and the seed heads make interesting subjects to paint. As children when we were stung by stinging nettles we used to rub the leaves of a dock on the skin to ease the pain.

STEMLESS THISTLE These grow on chalky soil like rosettes close to the ground.

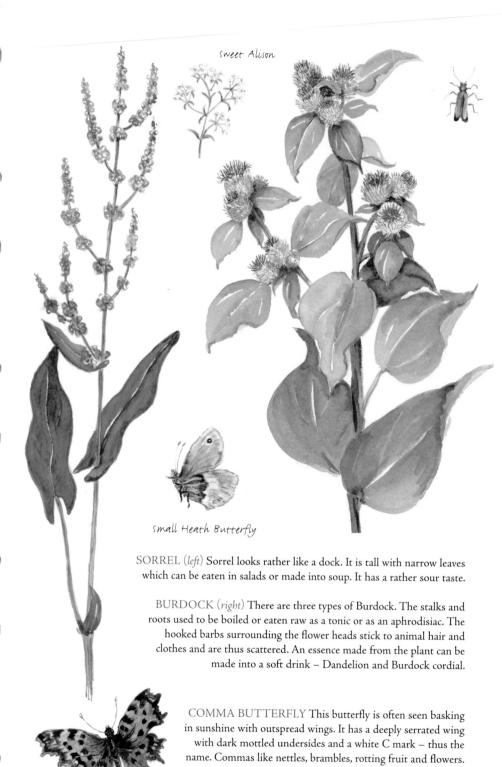

sweet Alison

small Heath Butterfly

SORREL (*left*) Sorrel looks rather like a dock. It is tall with narrow leaves which can be eaten in salads or made into soup. It has a rather sour taste.

BURDOCK (*right*) There are three types of Burdock. The stalks and roots used to be boiled or eaten raw as a tonic or as an aphrodisiac. The hooked barbs surrounding the flower heads stick to animal hair and clothes and are thus scattered. An essence made from the plant can be made into a soft drink – Dandelion and Burdock cordial.

COMMA BUTTERFLY This butterfly is often seen basking in sunshine with outspread wings. It has a deeply serrated wing with dark mottled undersides and a white C mark – thus the name. Commas like nettles, brambles, rotting fruit and flowers.

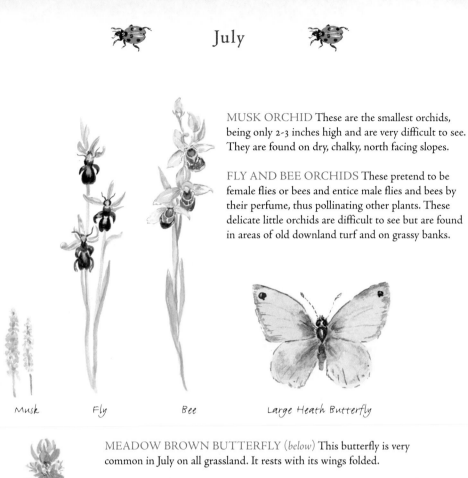

MUSK ORCHID These are the smallest orchids, being only 2-3 inches high and are very difficult to see. They are found on dry, chalky, north facing slopes.

FLY AND BEE ORCHIDS These pretend to be female flies or bees and entice male flies and bees by their perfume, thus pollinating other plants. These delicate little orchids are difficult to see but are found in areas of old downland turf and on grassy banks.

Musk    Fly    Bee    Large Heath Butterfly

MEADOW BROWN BUTTERFLY (below) This butterfly is very common in July on all grassland. It rests with its wings folded.

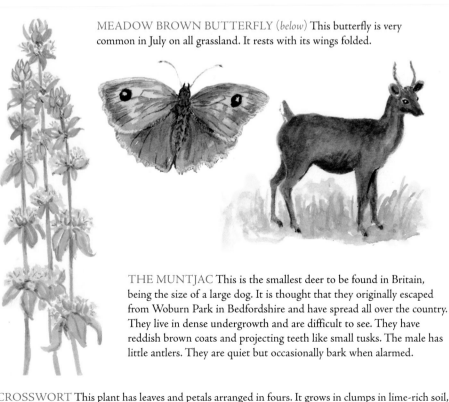

THE MUNTJAC This is the smallest deer to be found in Britain, being the size of a large dog. It is thought that they originally escaped from Woburn Park in Bedfordshire and have spread all over the country. They live in dense undergrowth and are difficult to see. They have reddish brown coats and projecting teeth like small tusks. The male has little antlers. They are quiet but occasionally bark when alarmed.

CROSSWORT This plant has leaves and petals arranged in fours. It grows in clumps in lime-rich soil, flowering May-July, giving off a strong honey-like smell which attracts pollinating insects.

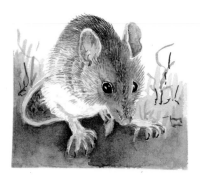

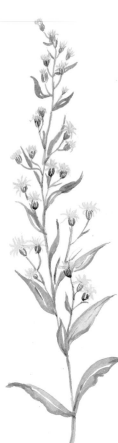

Foxglove

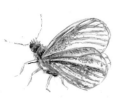

WOODMOUSE This nocturnal mouse has larger ears and eyes and a browner coat than a house mouse. It eats seeds and berries and is found in wooded areas.

WOOD WHITE BUTTERFLY This is a small diaphanous, flimsy looking butterfly, commonly found in woods.

GOLDEN ROD Unlike the garden variety these have single rays of fewer flowers. It is found in woodland where they grow up to 3 feet. If they are found in heathland they are much shorter.

FOXGLOVE *Digitalis* from the Latin word for finger, it is a well-known and much loved woodland plant; however, all parts are poisonous. It is used in medicine to treat heart problems.

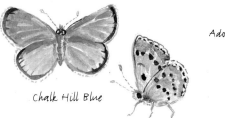

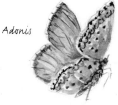

Adonis

Chalk Hill Blue

BLUE BUTTERFLIES These are very small and extremely difficult to identify. They are found on chalk downland liking scabious, black knapweed and thistles.

COMMON FIELD GRASSHOPPER (*right*) These vary from green to brown. They are found in dry grassy places. They are similar to the mottled grasshopper which is found on heaths and downland.

WOOD ANT (*below left*) These live in large colonies on the woodland floor, building nests of leaves and sticks.

SMALL SKIPPER BUTTERFLY (*below middle*) A meadow butterfly found in July-August. It has upper orange wings with lighter underwings. It rests with wings at an angle. It likes thistles and daisies.

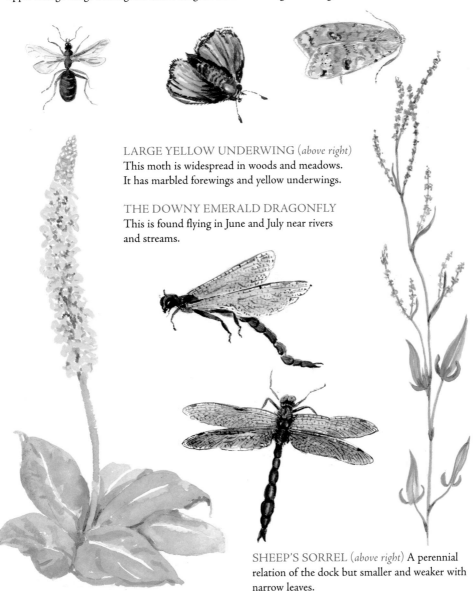

LARGE YELLOW UNDERWING (*above right*) This moth is widespread in woods and meadows. It has marbled forewings and yellow underwings.

THE DOWNY EMERALD DRAGONFLY This is found flying in June and July near rivers and streams.

SHEEP'S SORREL (*above right*) A perennial relation of the dock but smaller and weaker with narrow leaves.

GREAT MULLIEN (*above*) This is a wild Verbascum with woolly whitish leaves and a tall spire covered in yellow flowers, and very common on chalky soil. They can grow very tall.

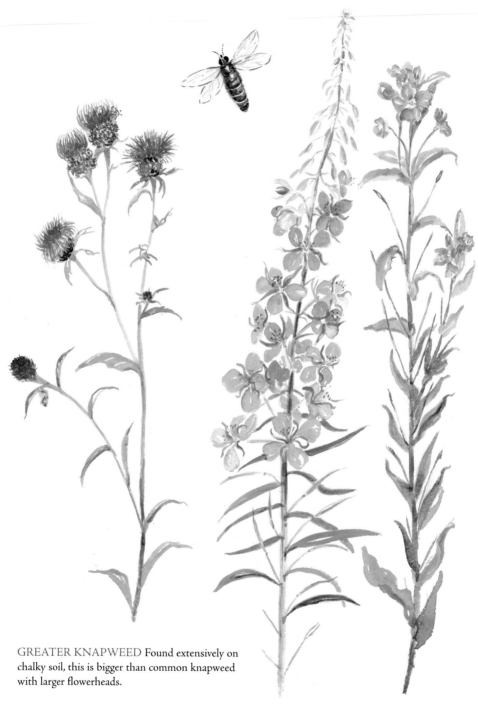

GREATER KNAPWEED Found extensively on chalky soil, this is bigger than common knapweed with larger flowerheads.

ROSEBAY WILLOWHERB Named after its long narrow willow-like leaves, it is abundant along verges and hedgerows growing up to 6 feet tall. Long seedpods burst and fluffy seeds are expelled and carried in the wind.

Great Hairy Willowherb

August was named after the
Roman Emperor Augustus

St Bartholomew's Day
– 24 August

# AUGUST

'All the tears St Swithin can cry,
St Bartholomew's mantel wipes them dry

If 24 August be fair and clear
Then hope for a prosperous autumn that year'

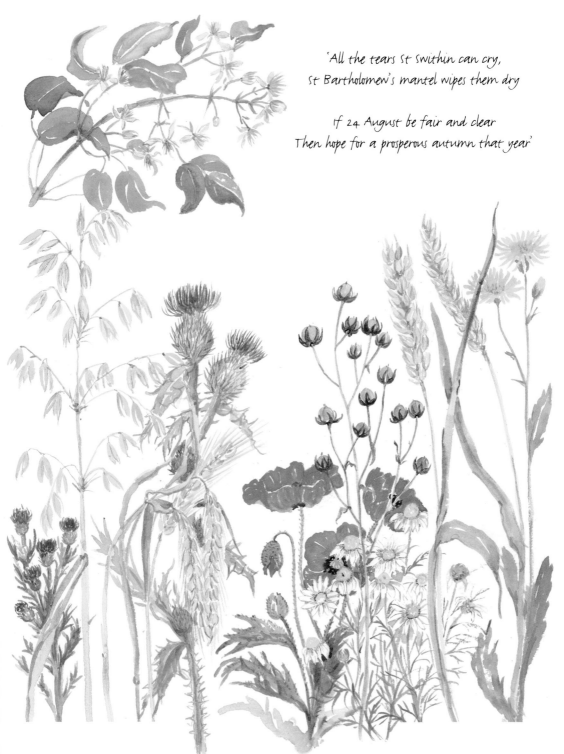

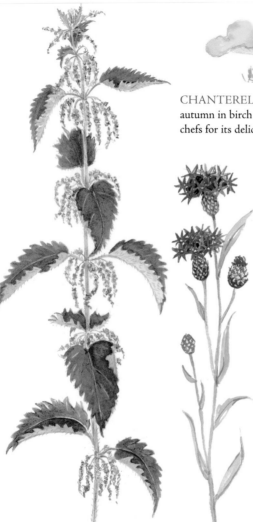

CHANTERELLE These fungi appear from late July until autumn in birch and hazel coppices. It is highly prized by chefs for its delicate flavour. They have an apricot-like smell.

Brimstone moth

CORNFLOWER (*left*) These popular garden flowers used to be found in the cornfields but rarely nowadays.

CHICORY (*right*) This is found on the edge of cornfields and cultivated ground. It is a tall, chalk-loving plant with beautiful sky blue flowers. Its root used to be dried and roasted and used as a substitute for coffee.

STINGING NETTLE The common nettle is the scourge of farmers and gardeners. However, it was once considered valuable. Nettle beer was made from young tops which can also be boiled and served as a vegetable like spinach. Before cotton was imported the dried stems were spun and made into coarse cloth or made into rope. The stinging hairs have a pointed single cell above the bulbous base holding the poison.

'Tender-handed pick a nettle,
it will prick you for your pains.
Treat it like a man of metal,
soft as velvet it remains'

HUMMINGBIRD HAWK MOTH CATERPILLAR Found on bedstraw plants in July and August.

MEADOWSWEET Found in damp meadows and woods and at the edge of ponds and lakes, it flowers from June-September, has a very strong sweet smell, and was used in the making of mead. In Elizabethan times, it was strewn on floors. It is also known as Bridewort or Meadwort.

CAT'S EAR This is common on all pasture land, flowering in July and August.

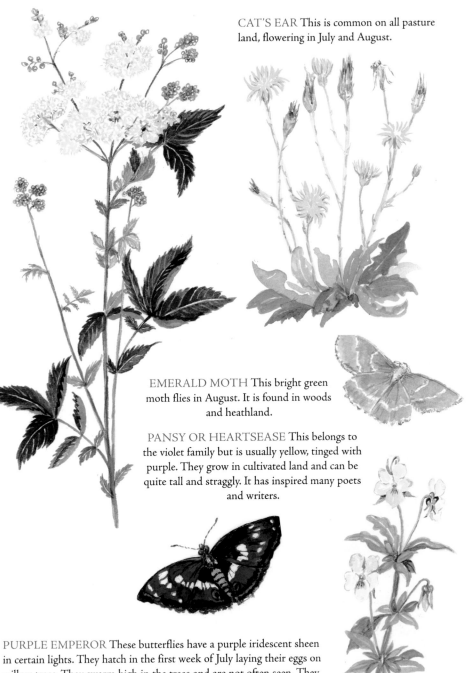

EMERALD MOTH This bright green moth flies in August. It is found in woods and heathland.

PANSY OR HEARTSEASE This belongs to the violet family but is usually yellow, tinged with purple. They grow in cultivated land and can be quite tall and straggly. It has inspired many poets and writers.

PURPLE EMPEROR These butterflies have a purple iridescent sheen in certain lights. They hatch in the first week of July laying their eggs on willow trees. They swarm high in the trees and are not often seen. They feed on carrion and animal droppings.

MARBLED WHITE These attractive butterflies appear in July-September in colonies where there are areas of old downland turf. The larvae feed on Sheep's Fescue grass. They hibernate in winter in the dead grass.

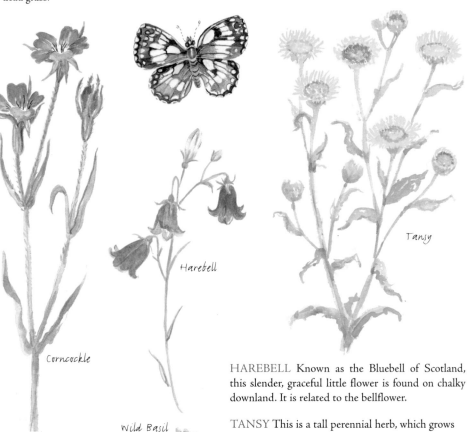

Corncockle

Harebell

Tansy

Wild Basil

HAREBELL Known as the Bluebell of Scotland, this slender, graceful little flower is found on chalky downland. It is related to the bellflower.

TANSY This is a tall perennial herb, which grows on verges and damp fields. It has a strong, spicy scent and bitter taste, and was used as a medicine to staunch wounds and prevent miscarriages. It was also used as a flavouring and in Tansy pudding.

CLOUDED YELLOW BUTTERFLY These are quite rare summer visitors. They feed on thistle, knapweed, clover and marjoram. They arrive in colonies in August and can be seen until September. They move swiftly and are hard to see while resting.

Wild Marjoram

 # August

NIGHTJAR (*below left*) These are migratory birds which arrive from Africa in May, leaving in August-September. They prefer heath and common land. They fly only at night; their strange camouflage makes them very difficult to see. They make an eerie churring sound.

EYED HAWKMOTH (*below right*) Its marbled grey-brown forewings hide the hindwings at rest. When disturbed it arches its wings exposing eyespots to deceive predators.

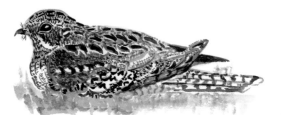
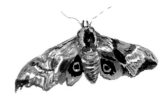

PIGEON (*right*) looking for corn in harvested fields.

KINGFISHER (*below*) This small, brightly coloured bird is found near water but rarely seen. Often all that appears is a flash of blue and orange. They have a loud, high pitched, bell-like ringing call. They feed on fish and aquatic invertebrates perching over the water and plunging in after their prey. They nest in holes in the banks beside streams and ponds.

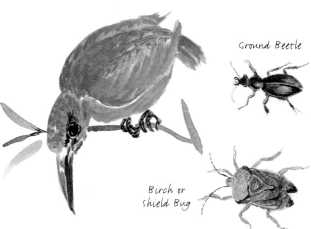

Ground Beetle

Birch or
Shield Bug

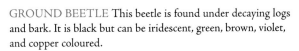

GROUND BEETLE This beetle is found under decaying logs and bark. It is black but can be iridescent, green, brown, violet, and copper coloured.

SHIELD BUG It is well camouflaged, being mainly green with black spots, found on hazel and birch.

ST JOHN'S WORT There are fourteen species of this plant. The common variety is found all over, particularly on chalk in fields and woods. It used to be thought to stop bleeding and is now used as a herbal remedy for anxiety.

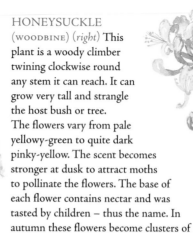

HONEYSUCKLE (WOODBINE) (*right*) This plant is a woody climber twining clockwise round any stem it can reach. It can grow very tall and strangle the host bush or tree. The flowers vary from pale yellowy-green to quite dark pinky-yellow. The scent becomes stronger at dusk to attract moths to pollinate the flowers. The base of each flower contains nectar and was tasted by children – thus the name. In autumn these flowers become clusters of berries which are enjoyed by birds.

HEDGE OR GREATER BINDWEED (*left*) This prolific plant climbs around nettles and hogweed reaching great heights and has large white flowers. It has a large root structure and as a weed is difficult to eliminate.

HAWFINCH This unusual finch lives in mature woodlands where it feeds off the seeds of hornbeam and wild cherry. It has a large conical beak used for cracking the hard seeds and cherry stones.

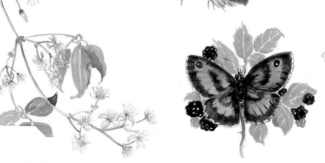

TRAVELLER'S JOY (*above*) A wild clematis which climbs throughout hedgerows and thickets.

GATEKEEPER (*middle*) This butterfly is also known as the Hedge Brown due to its habitat in the hedgerows. It has bright orange markings.

LESSER OR FIELD BINDWEED (*right*) This plant entwines around nettles and thistles in the hedgerows, and also spreads on the ground on banks and the edges of fields.

# August

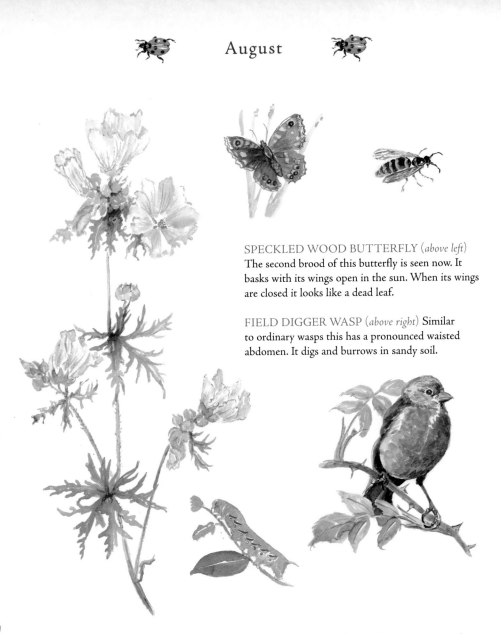

SPECKLED WOOD BUTTERFLY (*above left*)
The second brood of this butterfly is seen now. It basks with its wings open in the sun. When its wings are closed it looks like a dead leaf.

FIELD DIGGER WASP (*above right*) Similar to ordinary wasps this has a pronounced waisted abdomen. It digs and burrows in sandy soil.

MALLOW (*above left*) This is the wild version of the garden Malva and Lavateria. It grows in meadows, verges, hedgerows, and on banks. After the flowers have disappeared the plant becomes ragged and untidy, and is eaten by snails, and used to be called 'Rags and Tatters'. Mallow was used for medicinal purposes, the leaves and roots blended into soothing poultices.

PRIVET HAWKMOTH CATERPILLAR (*above middle*) These live on privet, lilac or ash.

LINNET (*above right*) These birds live in large flocks, often in cornfields, where there is plenty of food after harvest in late summer and autumn. Some birds move south to the continent for the winter while some arrive from Scandinavia to overwinter here. In summer the male has a pink crown and breast, which it loses in the winter. The female stays the same so then they both look similar. They nest near the ground feeding on seeds and insects. White patches on their wings and tails make them noticeable in flight.

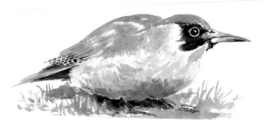

Fat Hen

GREEN WOODPECKER OR YAFFLE These colourful birds live in well-wooded areas, but can be seen in fields and gardens looking for ants. The female has less crimson on its head and the young are a mottled grey-green. Their plumage becomes browner in late summer. They have a loud laughing cry and make a drumming noise while seeking insects from under the bark or boring a hole for its nest in mid-April, making a new one each year. They have an undulating flight and hop awkwardly on the ground. Unlike most birds which have three forward facing claws, they have two forward facing and two rearward facing, which are ideal for climbing vertical trunks. They never perch or climb downwards. They ascend spirally and then fly down to the base. They have a sticky tongue and a short stiff tail which they use to balance.

Wild Thyme

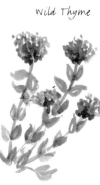

Toadflax

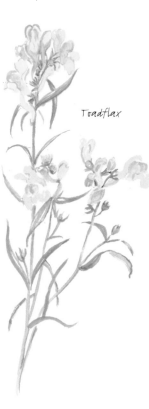

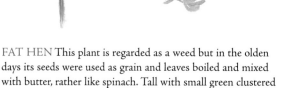

FAT HEN This plant is regarded as a weed but in the olden days its seeds were used as grain and leaves boiled and mixed with butter, rather like spinach. Tall with small green clustered flowers, its seeds are black and shiny with a high fat content.

TOADFLAX This is a wild snapdragon. A flower head lying on its back resembles a young frog emerging from its tadpole stage which gives it its name. Found on the downs on cultivated land.

 # August

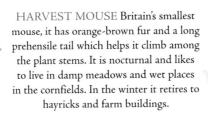

**HARVEST MOUSE** Britain's smallest mouse, it has orange-brown fur and a long prehensile tail which helps it climb among the plant stems. It is nocturnal and likes to live in damp meadows and wet places in the cornfields. In the winter it retires to hayricks and farm buildings.

**COMMON CENTUARY** These clusters of pink flowers on a thin stalk are found in dry pastures and chalky soil.

**FIELD CRICKET** This little insect is very rare; there are only a few colonies in this area. In early summer it sits in the sunshine outside its burrow making a lovely chirruping sound. It does not fly but jumps. Its under-developed wings are ridged and serrated which the males rub together to make the music. They are shiny black and the male has a yellow bar across the base of the wing covers. They live on sandy soil.

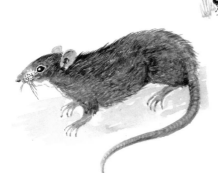

RAT These unpopular rodents are found everywhere, especially near human habitation where they thrive on refuse or near barns or farm buildings, where animals and birds are housed, where they scavenge feed and grain. They have been notorious throughout the ages for spreading disease.

NIPPLEWORT This common plant grows on waste ground. It is tall with lots of small yellow flowerheads.

MAGPIE MOTH These are found in hedgerows and gardens. It is a fragile weak-flying moth. The patterns vary but it has a black and yellow abdomen.

COMMON GREEN GRASSHOPPER These are hard to see in the grass. They make a 'singing' noise by rubbing the rough edge of their legs on a ridge on their wing. Their large hind legs are used for jumping.

CREEPING THISTLE This widespread and common weed is the scourge of farmers. Its fluffy seed heads are blown all over by the wind, making them very prolific.

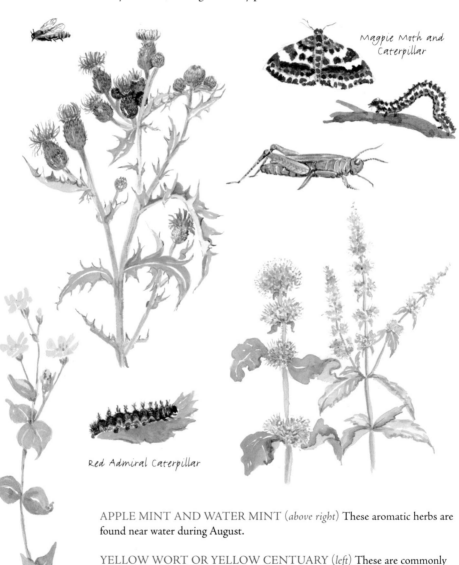

Magpie Moth and Caterpillar

Red Admiral Caterpillar

APPLE MINT AND WATER MINT (*above right*) These aromatic herbs are found near water during August.

YELLOW WORT OR YELLOW CENTUARY (*left*) These are commonly found on chalk from June to September. The lower margins of leaf are fused round the stem.

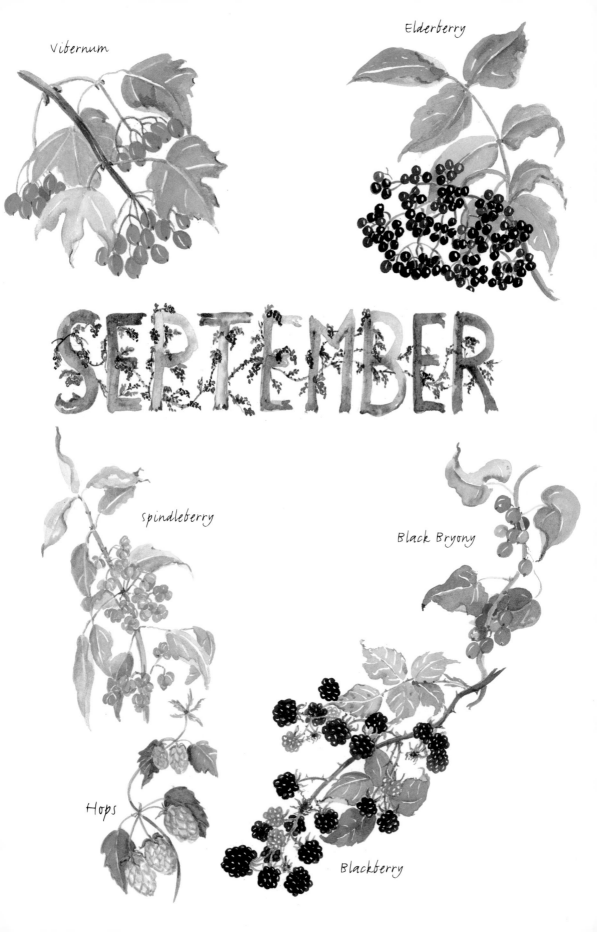

Vibernum

Elderberry

SEPTEMBER

Spindleberry

Black Bryony

Hops

Blackberry

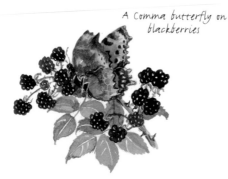

A Comma butterfly on blackberries

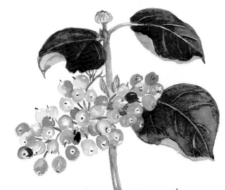

THE WAYFARING TREE (*right*) – also known as Guelder Rose. This is a large bush found on chalk soils. They have dark green leaves with pale downy undersides. The fruits ripen unevenly from yellow to green, red and then black making a multi-coloured cluster.

DEADLY NIGHTSHADE (*left*) One of Britain's most poisonous plants it produces a drug, belladonna, which means beautiful lady. The plant can grow tall flowering from June-August. It was used by theatrical folk to dilate the pupils making large and lustrous eyes.

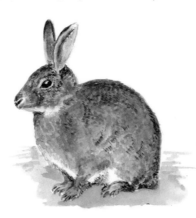

RABBIT These are found everywhere, although they prefer sandy areas to chalk. They breed all spring and summer. In the autumn they are prone to get the disease Myxomatosis and sick, blind rabbits are seen creeping about in the hedgerows.

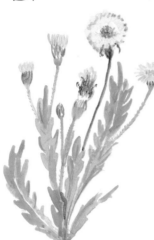

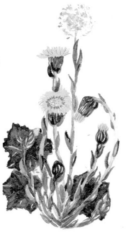

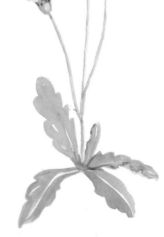

Some of the dozens of yellow flowers found at this time of year on downland fields, banks, and wasteland.

MOUSE-EARED HAWKWEED (*left*) One of 250 different varieties. Small dandelion-like flowers are borne on hairy stalks.

COLTSFOOT (*middle*) Found on grassland. The flowers appear before the leaves, flowering from early spring until autumn. The leaves are an unusual shape, like a shield resembling the imprint of a colt's foot. The plant has pink scaled stems. It was used as a cure for coughs.

ROUGH HAWKBIT (*right*) Rather like the dandelion but with tough stems. Flower heads droop when in bud.

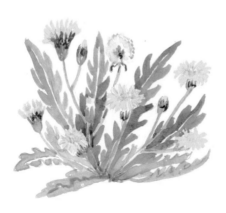

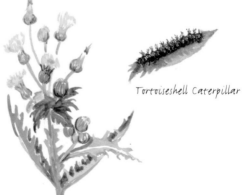

Tortoiseshell Caterpillar

AUTUMN HAWKBIT (*above left*) A common plant which can vary from very small to quite tall.

SOW THISTLE OR MILK THISTLE (*above right*) Tall herb which used to be eaten, it contains a milky substance. It is found on cultivated land and wasteland. It can be smooth or prickly.

Common Cat's Ear

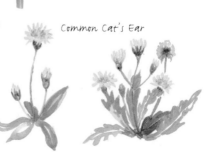

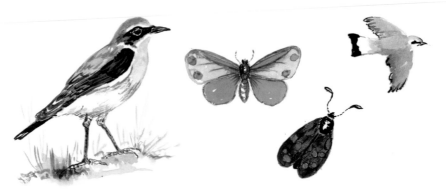

WHEATEAR (*right*) A summer visitor arriving in March and leaving in September. The male is striking with a black mask and bar on tail with an orange-buff breast. The female is rather plain with sandy-buff plumage. Both sexes show white rump in flight. It nests in burrows, and makes a 'chak' alarm sound.

BURNET MOTH (*middle*) This brightly coloured moth flies in daytime. The caterpillar feeds on trefoil and vetch. The moth tastes nasty and is poisonous so birds keep away. There are five or six spot burnets.

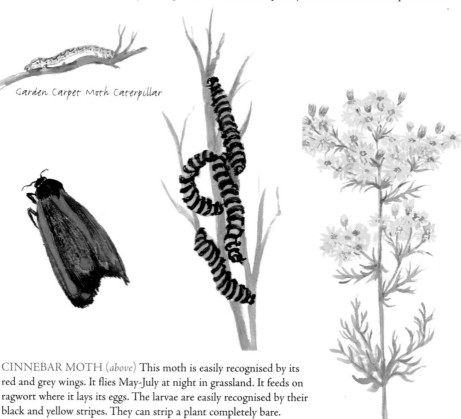

Garden Carpet Moth Caterpillar

CINNEBAR MOTH (*above*) This moth is easily recognised by its red and grey wings. It flies May-July at night in grassland. It feeds on ragwort where it lays its eggs. The larvae are easily recognised by their black and yellow stripes. They can strip a plant completely bare.

RAGWORT (*right*) This herb is widespread and a scourge to farmers. Dense clusters of yellow flowerheads create carpets of yellow in fields and wasteland. It is very poisonous if eaten by livestock but rarely eaten while alive; very palatable when dead.

ROE DEER These are smaller than the fallow deer and move about in small family groups. They are a chestnut colour in the summer and have small, white, puff like tails. They are shy and hard to see in the woods.

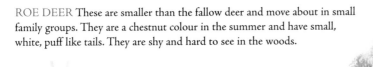

Hemp Agrimony

STONECHAT These small birds are found on heaths and commons. The male has a black head with white on the side and a reddish breast. The female is rather duller. It makes a harsh 'tchak' call like stones being knocked together. It flicks its tail when perching.

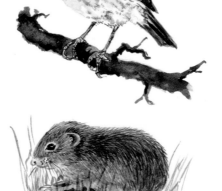

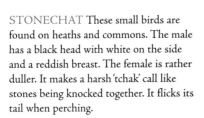

Black Bryony

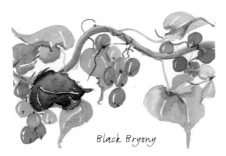

HEMP AGRIMONY This tall plant grows along river banks, shady meadows, and damp woods. The flowers are very attractive to butterflies.

FIELD VOLE A close relation of the rat and mouse, but it has a blunt nose, short tail, and tiny ears. They are very numerous living in hedgerows, rough grassland, and edges of fields. They are preyed upon by sparrowhawks and kestrels.

LONG-EARED BAT These
extraordinary little animals fold their
long ears behind their legs when asleep.
They have the largest ears of any animal in
proportion to its body. They live in barns and
outbuildings feeding on flies and insects.

STINKHORN These appear in late summer and autumn. A whitish ball appears on the ground
the size of an egg. As it becomes ripe the outer skin breaks and a white spongy tube 4-5 inches high
emerges within a few hours with a conical cap, and covered in a dark green sticky mass which breaks
down, creating a foul smell and spreading spores. They can be smelt before they are seen.

BRAMBLE WHISKY
1 bottle of whisky
1lb sugar
1lb blackberries
Put in large container, mix and
shake daily for a week.
Leave for six weeks. Strain and drink.

ROUND HEADED RAMPION (*right*)
A relation to the bell-flower. Common
on chalk hills in July-September.

ARUM LILY OR CUCKOO PINT (*far right*)
The red fruit are very poisonous
appearing in September and October.

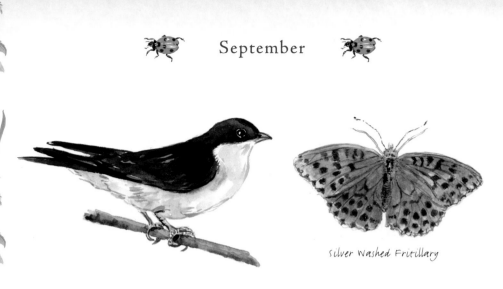

Silver Washed Fritillary

**HOUSE MARTIN** Like the swallow it is a summer visitor, arriving mid-April and leaving late August-early September. Identified in flight by white underparts, white rump, blue-black upper plumage and a shorter tail without long points like swallows. They build mud nests.

**SILVER WASHED FRITILLARY** The largest of the family this fritillary has greenish-yellow underwings with silvery marks running through – thus their name. They fly high in the tree tops looking like gold in the sunlight. The eggs are laid in crevices in the bark of trees – oak, beech, and whitebeam 2-3 feet above the ground where violets grow beneath. They hatch early autumn and the caterpillars hibernate under the bark. In spring they crawl down to the ground and feed on the violets. The butterflies can be seen in late summer.

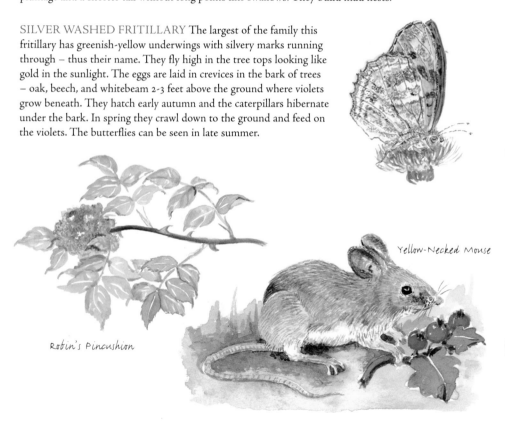

Yellow-Necked Mouse

Robin's Pincushion

**ROBIN'S PINCUSHION** This is a gall on a wild rose bush caused by gall wasps. In May the female wasp lays eggs in the unopened leaf-buds of a rose bush. The presence of the larvae causes the buds to develop into a bright red moss-like structure. The larvae remains in the gall all winter, hatching in May.

**THE YELLOW-NECKED MOUSE** This is similar to the woodmouse with a yellowish collar on its throat. It lives in woods and can climb trees.

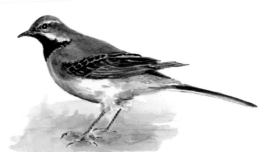

GREY WAGTAIL These elegant birds are always found near water. They are longer than the pied wagtail and often confused with the yellow wagtail which has less grey and black. They make the typical bobbing movement with their tails. They feed on aquatic insects.

WHITE BRYONY Although this plant has similar climbing habits as the Black Bryony, it is not related. It is a member of the melon and marrow family. It has long tendrils and is found rambling through the hedgerows with lots of dull red berries. It has figured in folklore and had a magical reputation, its roots supposedly being a powerful ingredient for love potions. It was thought in the past to be a mandrake.

COMMON AGRIMONY This grows on banks, the edge of fields and hedgerows. The small, sweetly smelling flowers are borne on long spires. The seeds are surrounded by small hooks which attach themselves to animals and passers-by. It was thought to have medicinal properties and was made into tea and used as an antidote for snake bites.

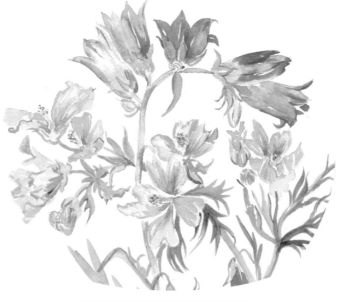

MALLOW AND BELLFLOWER
Often found together on grassy banks.

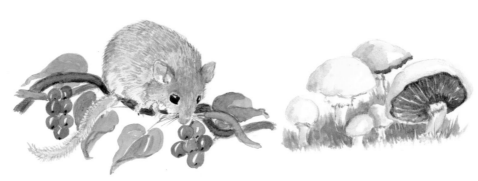

DORMOUSE This pretty and elusive little mouse is occasionally seen in summer months looking for nuts and berries. It builds expertly woven nests made of leaves and moss shaped like a ball in the cleft of a sapling or small tree. Between spring and autumn it feeds at night on buds, flowers, nuts, seeds, and berries. During the day it sleeps curled in a ball. Its name could be derived from the French *dormir*, to sleep. It is a light chestnut colour with large eyes and a bushy tail. It has two-seven babies, sometimes in two broods. It gorges itself before hibernating in September.

FIELD MUSHROOM These are found on old pasture, often where horses have grazed.

WOODY NIGHTSHADE OR BITTERSWEET This flowers from June to September in woods and hedges, climbing and rambling in the undergrowth. The flowers are like those of a potato. Berries turn from green to red all at the same time. It is called Bittersweet because the berries at first taste sweet – then bitter. They are poisonous and cause sickness.

Woody Nightshade

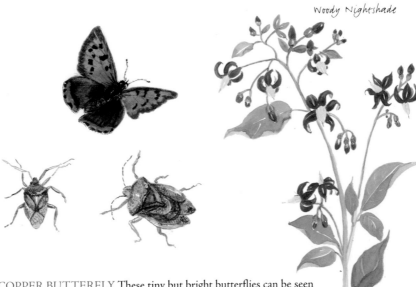

SMALL COPPER BUTTERFLY These tiny but bright butterflies can be seen this month flying from May until September. Larvae feed on Sheep's Sorrel.

HAWTHORN SHIELD BUG These feed mostly on hawthorn berries, but also on other plants when hawthorn is unavailable. They are found in hedgerows and woods.

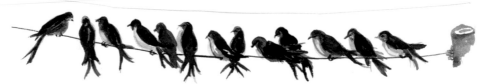

SWALLOW Swallows ready to leave for Africa. Swallows arrive from Africa in the second week of April and leave in the second week of September. They return to their same nest in open barns every year and raise two broods. Before they fly home they congregate on telegraph wires in large groups.

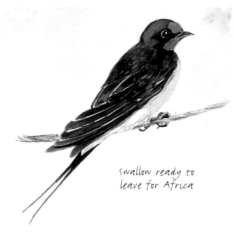

RED ADMIRAL BUTTERFLY These butterflies are summer migrants but many overwinter in sheds and barns. The larvae feed on nettles.

RED UNDERWING MOTH These fly from August to September in open woodlands. They have red and black barred underwings which are concealed at rest. Larvae are found on willows and poplars.

swallow ready to leave for Africa

COMMON EARWIG Found in leaf litter and under stones and logs. Flightless, they are most active after dark. They feed on dead organic matter.

Red Admiral

Red Underwing Moth

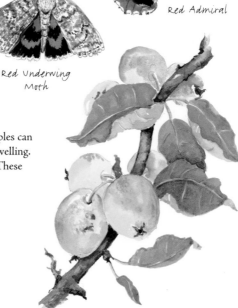

CRAB APPLE These tiny and colourful wild apples can be found everywhere, often a sign of an ancient dwelling. A branch of apples make good subjects to paint. These hard and bitter fruits make good jelly.

CRAB APPLE JELLY
1lb strained pulp
1lb jam sugar
Boil until sugar is well dissolved
and then strain through a jelly cloth.

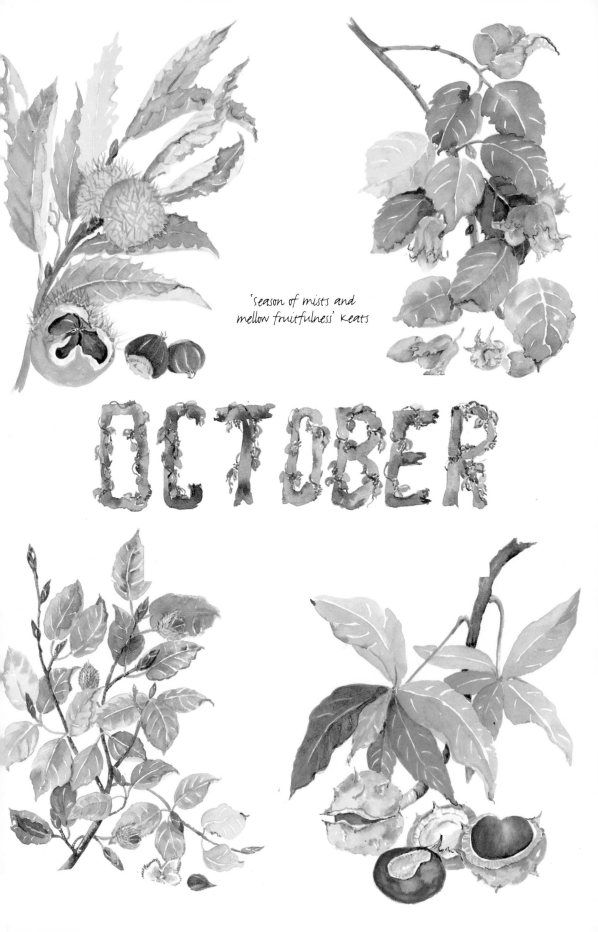

'season of mists and
mellow fruitfulness' Keats

OCTOBER

OCTOBER is the eighth month of the old Roman year and it is probably one of the best months of the year for artistic inspiration. The leaves are beginning to turn yellow – gold-pink and red and there are still plenty of flowers. On bright autumn days butterflies are still seen in the sun. The hedgerows are amass with rambling honeysuckles, blackberries, bryony and Old Man's beard. Conkers, sweet chestnuts, hazelnuts, acorns and beechnuts all make lovely subjects to paint.

SOUTHERN HAWKER This is usually seen near water but can also be seen glinting in the woodlands where it hawks or hunts.

BINDWEED This is seen climbing up a giant Hogweed. It is one of the last flowers of summer, seen on banks and hedgerows.

Yew Berries

Sloes

## SLOE GIN
1½ pints of sloes
¾lb loaf sugar or sugar candy
1 quart of gin
A few drops of almond extract
Prick sloes and put in jars. Add other ingredients. Cover tightly.
Shake from time to time. After 3-4 months strain, bottle and store.
The sloes can be kept for flavouring.

*NB* I have always been told that sloes are best after a frost,
but they can be placed in deep freeze.

## ROWAN JELLY
Rowan berries, sugar and water.
Peeled rind of lemon and 2 cloves (tied together in muslin).
Pick berries from stalks, wash and put in pan with enough water to cover.
Simmer until pulp. Strain. Measure juice, allowing 1 lb sugar to each pint.
Boil until set. (This jelly does not always set firm).
Excellent with game or red meat.

Rowan

Acorns

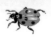 
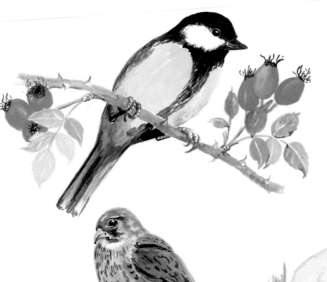

GREAT TIT The largest member of the tit family, recognised by the black stripe down its middle underside and black and white head pattern. It makes a 'teecha, teecha, teecha' sound.

KESTREL Britain's most common bird of prey feeding on small mammals and insects. They are often seen hovering over motorway verges looking for prey and swooping down on it.

PUFFBALL These fungi grow abundantly on chalk downland and fields, and can grow to the size of a football. If picked young they are delicious sliced and fried. Or you can chop with onions and parsley, sautée in butter, add some stock and boil and puree into soup. When they are old they turn brown and puffy. Once they were put on wounds, or dried and used for kindling.

WALNUT These grow profusely in the south of England. They were brought here by the Romans from Turkey. They come into leaf in May, later than most trees. In September the fruits are like large green plums. At this stage they can be pickled in vinegar and spices. Walnut wood is valuable and is used to veneer and decorate fine furniture. The tree can live for 200 years. In October the green husks turn to brown and expose the nuts. These husks make a brown dye.

# October

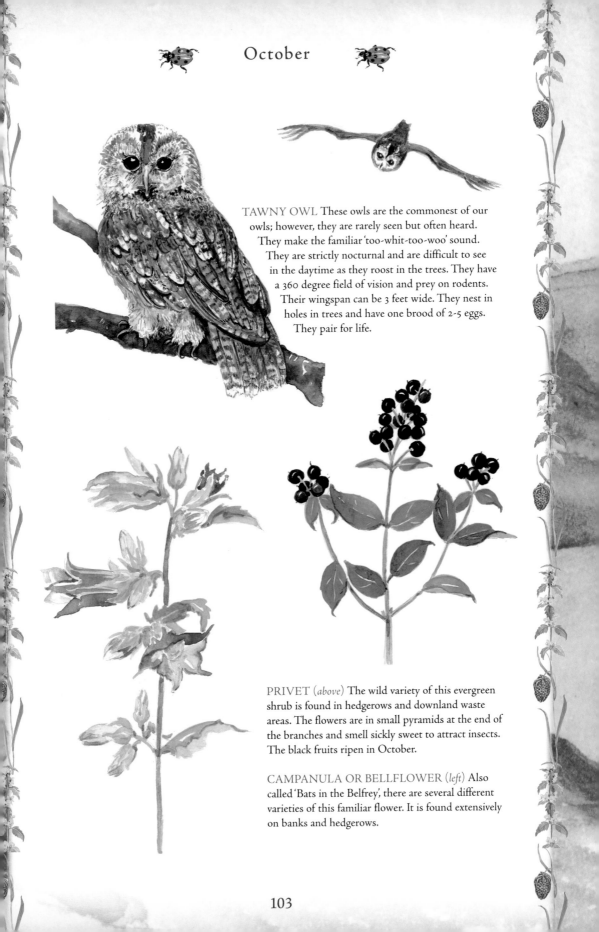

**TAWNY OWL** These owls are the commonest of our owls; however, they are rarely seen but often heard. They make the familiar 'too-whit-too-woo' sound. They are strictly nocturnal and are difficult to see in the daytime as they roost in the trees. They have a 360 degree field of vision and prey on rodents. Their wingspan can be 3 feet wide. They nest in holes in trees and have one brood of 2-5 eggs. They pair for life.

**PRIVET** (*above*) The wild variety of this evergreen shrub is found in hedgerows and downland waste areas. The flowers are in small pyramids at the end of the branches and smell sickly sweet to attract insects. The black fruits ripen in October.

**CAMPANULA OR BELLFLOWER** (*left*) Also called 'Bats in the Belfrey', there are several different varieties of this familiar flower. It is found extensively on banks and hedgerows.

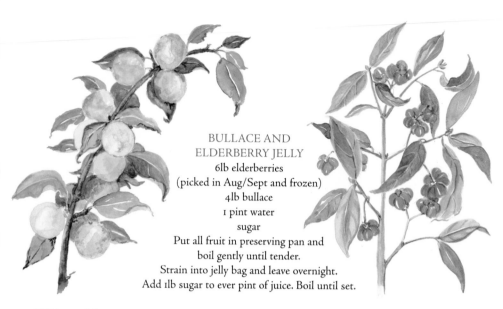

BULLACE AND
ELDERBERRY JELLY
6lb elderberries
(picked in Aug/Sept and frozen)
4lb bullace
1 pint water
sugar
Put all fruit in preserving pan and
boil gently until tender.
Strain into jelly bag and leave overnight.
Add 1lb sugar to ever pint of juice. Boil until set.

BULLACE This is a wild damson found occasionally in the hedgerows and thickets. The flowers come out before the leaves.

SPINDLE These small trees like lime-rich soil. It has small greenish flowers in May which ripen into lovely pink four-lobed capsules in September. These burst open in October, revealing bright orange flesh surrounding each hard yellow seed, attracting birds to disperse them. It is so named because it was once used as a stick around which wool was twirled during the spinning process. The thin stems of the spindle are hard and smooth and do not splinter. A circular stone weight with a hole was fixed to one end. These have been found on prehistoric sites.

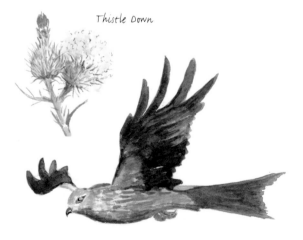

Thistle Down

RED KITE There are a few of these large birds of prey in this area. They are identified by their reddish chest, yellow bill, and forked tail.

THE BLUSHER This toadstool is commonly found in woodland from August-October. It has a buff cap, white gills. The stem has a ring and is pinkish near the base.

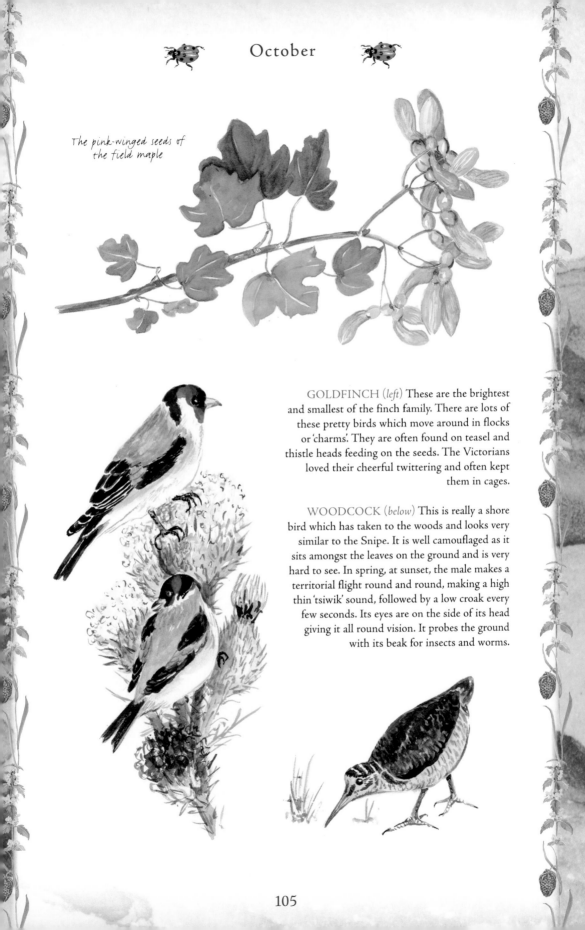

The pink-winged seeds of the field maple

GOLDFINCH (*left*) These are the brightest and smallest of the finch family. There are lots of these pretty birds which move around in flocks or 'charms'. They are often found on teasel and thistle heads feeding on the seeds. The Victorians loved their cheerful twittering and often kept them in cages.

WOODCOCK (*below*) This is really a shore bird which has taken to the woods and looks very similar to the Snipe. It is well camouflaged as it sits amongst the leaves on the ground and is very hard to see. In spring, at sunset, the male makes a territorial flight round and round, making a high thin 'tsiwik' sound, followed by a low croak every few seconds. Its eyes are on the side of its head giving it all round vision. It probes the ground with its beak for insects and worms.

SPOTTED WOODPECKER These birds live in oak woods and tall hedgerows with large old ash trees. They bore holes and make their nests high in dead trees, returning to the same tree year after year often boring new holes, where they lay 5-7 eggs. They eat insects, fruit acorns, beech mast, and fir seeds. They do not sing but make an alarm 'churk' sound and drum like the green woodpecker. They are rarely seen on the ground.

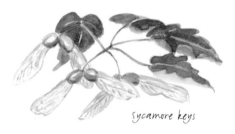

*sycamore keys*

STAG BEETLE These are named by the huge mandibles (jaws resembling stag's horns). They are not very strong and are really used to threaten and wrestle with other with other males. They are quite harmless although the female, which looks less aggressive and has no mandible, can nip. They are often found near oak trees and they fly in the summer evenings.

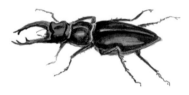

JUNIPER These slow growing evergreen shrubs can occasionally be found on the steep chalky slopes of the Southdowns, although they are mostly found in Scotland. They have small yellow flowers in May-June and berries in autumn. These are green and can remain on the bush for two or three years before they ripen to a blue-black. They are aromatic and are used to flavour gin. The dried berries are often added to game stews.

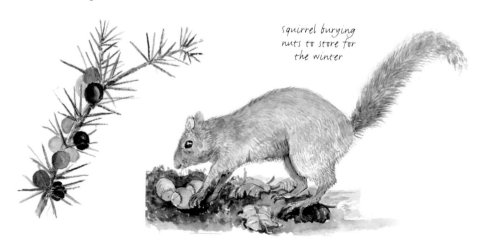

*squirrel burying nuts to store for the winter*

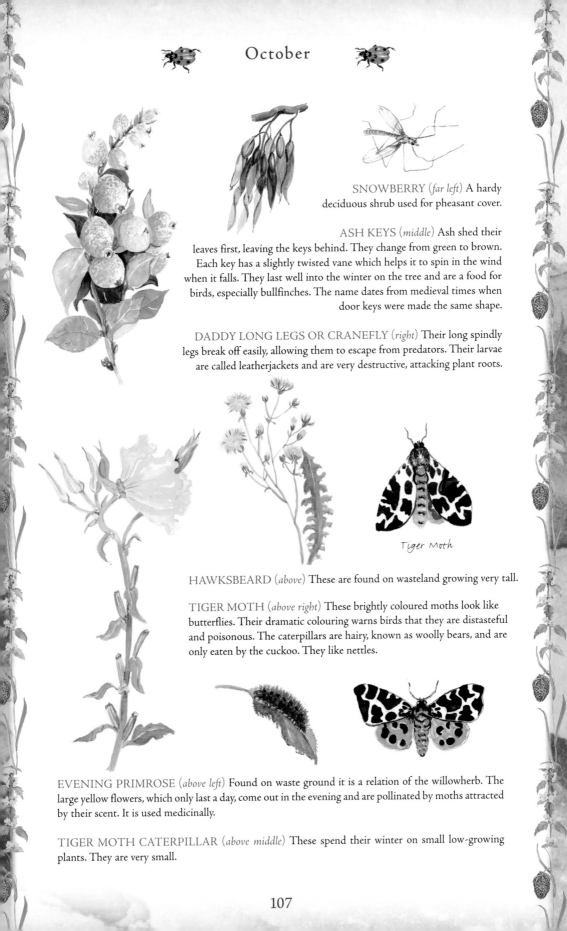

SNOWBERRY (*far left*) A hardy deciduous shrub used for pheasant cover.

ASH KEYS (*middle*) Ash shed their leaves first, leaving the keys behind. They change from green to brown. Each key has a slightly twisted vane which helps it to spin in the wind when it falls. They last well into the winter on the tree and are a food for birds, especially bullfinches. The name dates from medieval times when door keys were made the same shape.

DADDY LONG LEGS OR CRANEFLY (*right*) Their long spindly legs break off easily, allowing them to escape from predators. Their larvae are called leatherjackets and are very destructive, attacking plant roots.

Tiger Moth

HAWKSBEARD (*above*) These are found on wasteland growing very tall.

TIGER MOTH (*above right*) These brightly coloured moths look like butterflies. Their dramatic colouring warns birds that they are distasteful and poisonous. The caterpillars are hairy, known as woolly bears, and are only eaten by the cuckoo. They like nettles.

EVENING PRIMROSE (*above left*) Found on waste ground it is a relation of the willowherb. The large yellow flowers, which only last a day, come out in the evening and are pollinated by moths attracted by their scent. It is used medicinally.

TIGER MOTH CATERPILLAR (*above middle*) These spend their winter on small low-growing plants. They are very small.

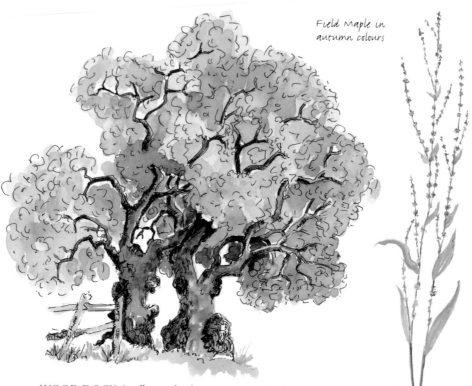

Field Maple in autumn colours

WOOD DOCK A tall straggly plant very commonly found in grassy woodlands, June–October.

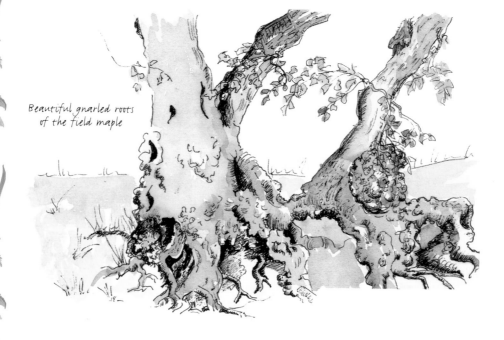

Beautiful gnarled roots of the field maple

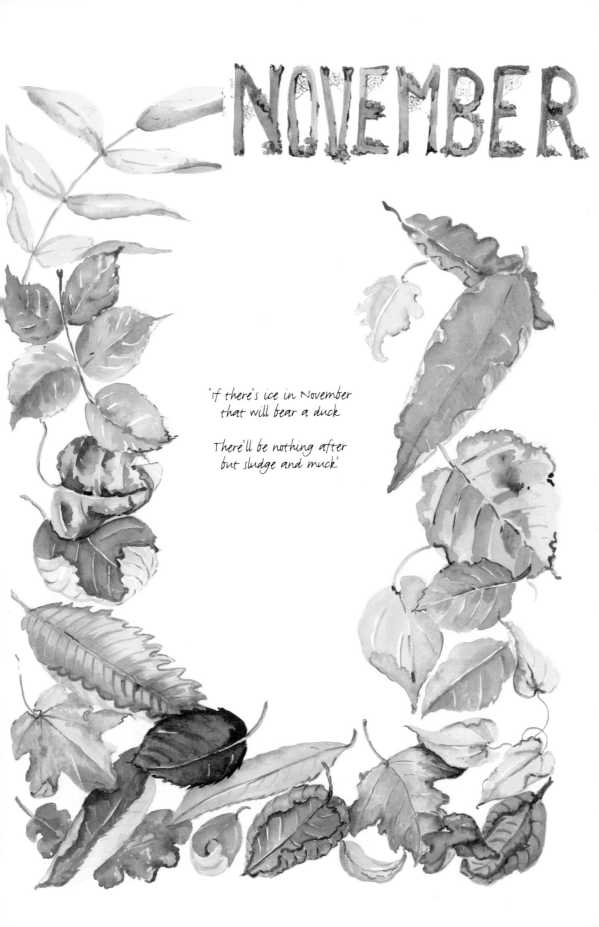

# NOVEMBER

'If there's ice in November
that will bear a duck

There'll be nothing after
but sludge and muck'

## Logs to Burn

Beechwood fires burn bright and clear
If the logs are kept a year.
Oaken logs burn steadily
If the wood is old and dry.
Chestnut is only good they say
If for long it's laid away.
But Ash new or Ash old
Is fit for a Queen with a crown of gold.

Birch and Fir logs burn too fast
Blaze up bright and do not last.
Make a fire with an elder tree
And death within your house you'll see.
It is by the Irish said
That Hawthorn bakes the sweetest bread.
But Ash green or Ash brown
Is fit for a Queen with a golden crown.

Elm and Gean burn like churchyard mould,
Even the very flames are cold.
Poplar gives a bitter smoke
And fills your eyes and makes you choke.
Apple wood will scent your room
With an incense-like perfume.
But Ash wet or Ash dry
A King shall warm his slippers by.

Anon

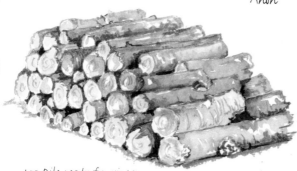

Log Pile ready for winter

Autumn and winter bonfires

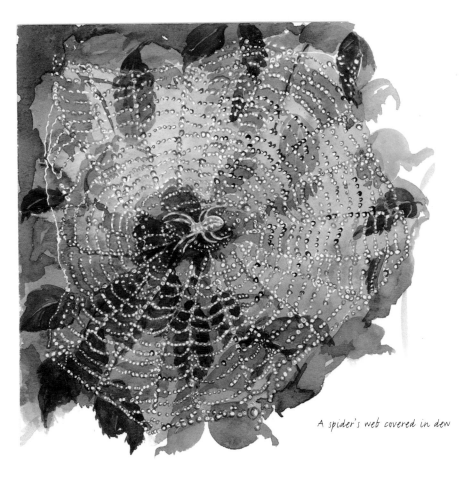

A spider's web covered in dew

BUZZARD These large birds of prey have become quite common around this area. They circle high overhead looking for their prey. Their eyesight is eight times sharper than ours. They plummet down when they see rabbits, mice or small rodents. They build their nests high in the trees. They make a strange high cry – rather like a lapwing.

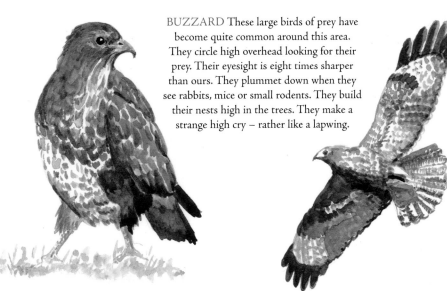

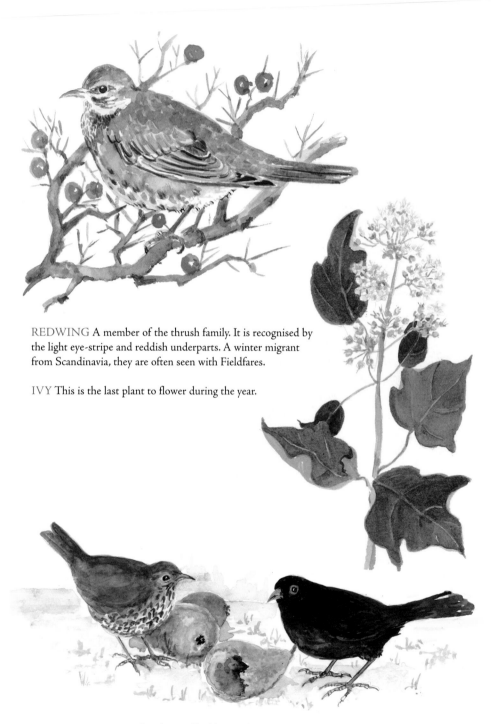

REDWING A member of the thrush family. It is recognised by the light eye-stripe and reddish underparts. A winter migrant from Scandinavia, they are often seen with Fieldfares.

IVY This is the last plant to flower during the year.

*Song Thrush and blackbird enjoying some rotting windfalls*

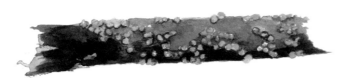

CORAL SPOT FUNGUS This tiny fungus is found on dead or dying branches of deciduous trees.

FUNGI These grow from spores – millions of them which are expelled onto the surrounding ground but only a few germinate. They can appear suddenly overnight. They are mostly seen in autumn but there are spring varieties. They play an important part in the health of the woodland, living on decaying wood and fallen branches, extracting sugar from their hosts and in turn they pass essential minerals to the plants. They provide food and shelter in the life cycle of hundreds of insects and other creatures. Some are edible; many are very poisonous.

FLY AGARIC This is often found beneath Silver Birch trees. The name comes from a practice that began in medieval times. The fungus was broken up and put into milk in order to stupefy flies.

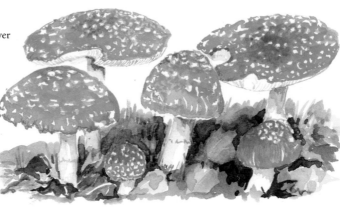

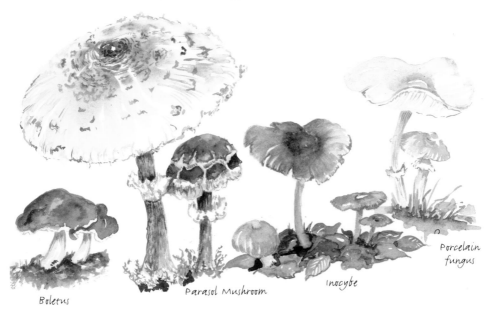

Boletus

Parasol Mushroom

Inocybe

Porcelain fungus

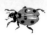 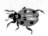

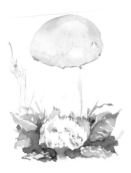 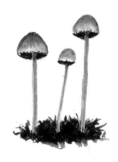 

DEATH CAP (*left*) This deadly poisonous fungus looks a bit like a mushroom but it is pale olive yellow capped with white gills. It grows in deciduous woods.

ORANGE PEEL FUNGUS (*right*) This bright orange fungus is widespread growing on the bare ground.

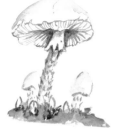  

DESTROYING ANGEL (*left*) This highly poisonous fungus is found in woods.

FAIRY RING CHAMPIGNON (*middle*) These typically form in rings in meadows, grasslands, and even lawns, especially after rain. They are a pale buff-tan with white gills.

WOOD BLEWIT (*right*) An edible fungus found in woodland and hedgerows.

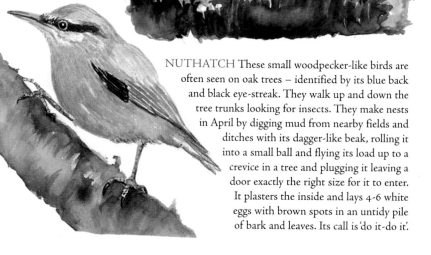

NUTHATCH These small woodpecker-like birds are often seen on oak trees – identified by its blue back and black eye-streak. They walk up and down the tree trunks looking for insects. They make nests in April by digging mud from nearby fields and ditches with its dagger-like beak, rolling it into a small ball and flying its load up to a crevice in a tree and plugging it leaving a door exactly the right size for it to enter. It plasters the inside and lays 4-6 white eggs with brown spots in an untidy pile of bark and leaves. Its call is 'do it-do it'.

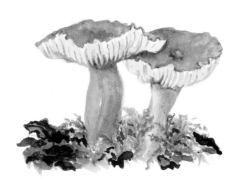 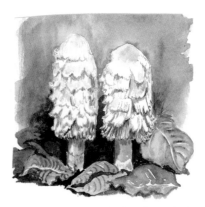

RUSSULA 'THE SICKENER' (*left*) This poisonous toadstool is widespread, found mostly in coniferous woods.

SHAGGY INKCAP (*right*) When it first appears the cap is oval and covered in curly white scales, thus its other name 'Lawyer's Wig'. As it matures the shaggy caps become black and a dark inky liquid containing the spores dribble down into the earth.

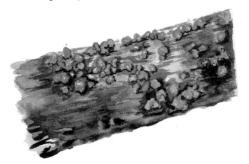 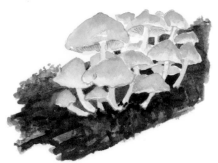

GREEN ELFCAP (*left*) These tiny green-blue fungi are found covering dead branches.

SULPHUR TUFT (*right*) This fungus is extremely common and found in large clumps on dead tree stumps and dead branches.

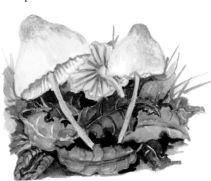 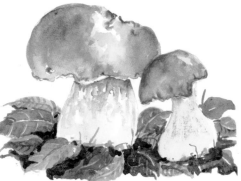

WOOD WOOLLY FOOT (*left*) This fungus is found in woods in late summer and autumn.

THE CEP (*right*) These edible fungi are considered a delicacy, especially in France. They are found in deciduous woodland.

MONEY SPIDER These tiny little black spiders can cover large areas of grass with a fine film of white web, often seen on a late autumn or winter morning glistening with dew, looking like silver which may give them their name.

A mossy log covered in many-zoned Polypore

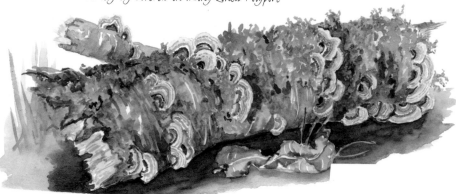

WOODY NIGHTSHADE The berries of the woody nightshade are found in the hedgerows during the autumn.

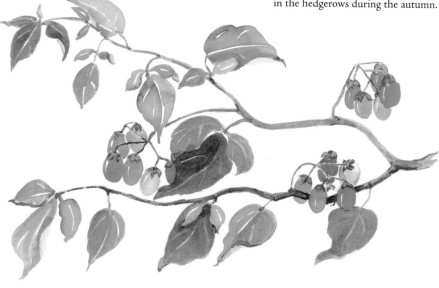

 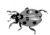

HOLLY is often known as 'Christ's Thorn'. Legend has it that the crown of thorns was made of holly, the fruits stained by the blood of Christ. It is considered unlucky to bring holly into the house before Christmas Eve and to leave it there after the old Christmas Day (6 January), Twelfth Night. The spiny leaved holly is referred to as 'he,' and the smooth leaved as 'she.'

MISTLETOE This is a partial parasite sucking goodness from the host tree. It is spread by birds who find the berries stuck to their beaks and rub them off on trees – often apple trees. The Druids thought mistletoe was sent by the gods and it was thought to be a great healer, rendering barren animals and humans fertile. It was never allowed to touch the ground or to be cut with anything iron. The Druid priests cut it with a golden sickle and the severed sprays were caught in a white cloth.

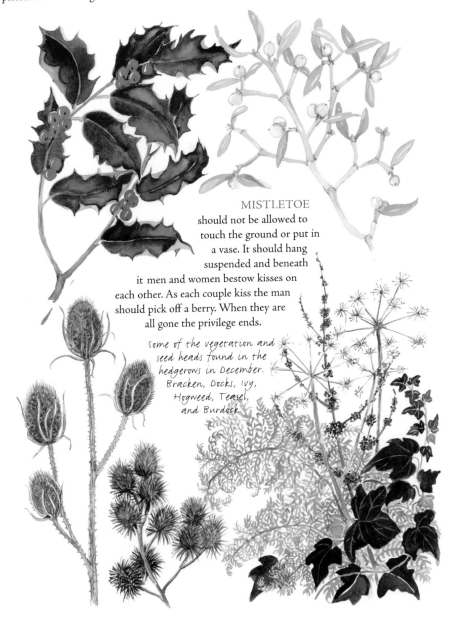

MISTLETOE
should not be allowed to
touch the ground or put in
a vase. It should hang
suspended and beneath
it men and women bestow kisses on
each other. As each couple kiss the man
should pick off a berry. When they are
all gone the privilege ends.

Some of the vegetation and
seed heads found in the
hedgerows in December.
Bracken, Docks, Ivy,
Hogweed, Teasel,
and Burdock.

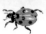 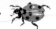

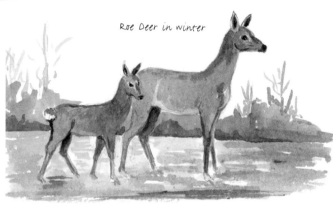

Roe Deer in winter

WOODLOUSE These crustaceans are the only land relative of the crab and shrimp. They need to keep moist and therefore live under logs and stones. They die very quickly if their bodies dry out. They eat dead leaves and wood and fruit in the autumn. They roll into a ball to escape danger.

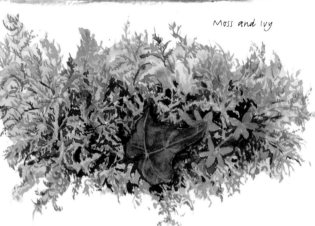

Moss and Ivy

IVY This plant uses trees only as a support. They gain nutrients from their roots deep in the soil beneath. There are two distinct life phases for the Ivy. In its early stage it has a fleshy stem and lobed leaves creeping along the ground until it reaches a tree. Then it climbs upwards, changing its form to oval unlobed leaves and bears flowers and fruit. It flowers in autumn and bears berries in December and January which are eaten by birds. Ivy, like holly, was thought to have magical powers. At Christmas it kept houses safe from demons and drunkenness.

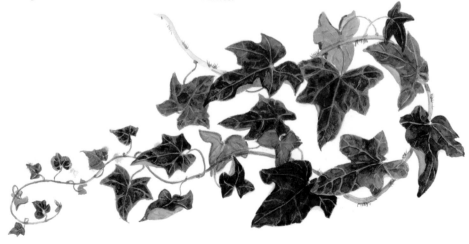

GREY HERON These are found near ponds and streams feeding on fish, frogs, and eels. Tall and long legged, it has a dagger-like yellow bill and a crest of black feathers. They can often be seen standing motionless beside water. In flight they move with a slow deliberate wing-beat with their legs trailing behind. They build huge nests in tall trees out of twigs, sometimes living in small colonies called heronries. They lay 4 eggs between February and May.

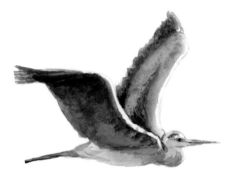

PINE This is a general name for 100 species of evergreen trees.

SCOTS PINE These elegant trees are native to Britain, associated with wild and windy places. They have short blue-green needles and pinkish-brown bark. In May it has clusters of male flowers shedding pollen and little red flowers which open at the tips of new shoots. Two types of cones can be seen in winter – one-year-old pea-sized brown cones at the end of the branches, and larger tapering green two-year-old cones maturing in spring. The scales turn brown and release winged seeds into the wind.

BROWN TROUT AND SEA TROUT Brown trout spend their entire life in freshwater. Sea trout migrate upstream to spawn some of them, reaching the narrow streams near their source at the bottom of the downs. In the old days, villagers could be seen with garden forks standing on the bridges overlooking the streams ready to harpoon them.

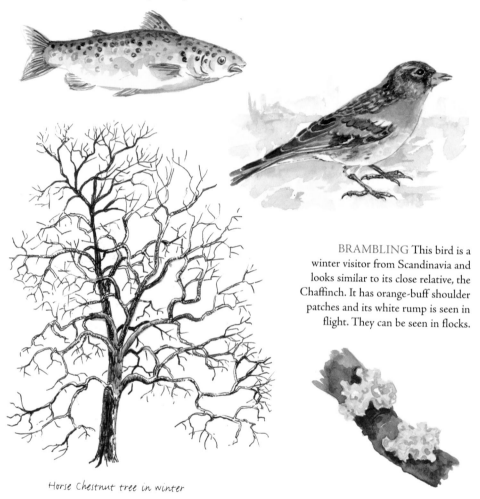

BRAMBLING This bird is a winter visitor from Scandinavia and looks similar to its close relative, the Chaffinch. It has orange-buff shoulder patches and its white rump is seen in flight. They can be seen in flocks.

Horse Chestnut tree in winter

YELLOW BRAIN FUNGUS This is found on dead wood from December to March.

A flock of rooks wheeling and swooping

LITTLE OWL These were introduced here in the latter part of the nineteenth century and are now quite a common sight. This is the smallest of the owl family with streaky grey-brown and white plumage. It has an obvious facial disc with glaring yellow eyes. It is often seen during the day, perching on gateposts and dead branches. It feeds on insects and earthworms and nests in walls and old buildings.

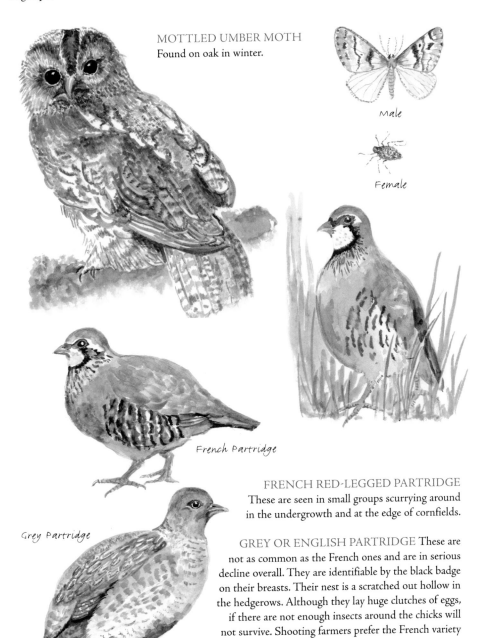

MOTTLED UMBER MOTH
Found on oak in winter.

Male

Female

French Partridge

Grey Partridge

FRENCH RED-LEGGED PARTRIDGE
These are seen in small groups scurrying around in the undergrowth and at the edge of cornfields.

GREY OR ENGLISH PARTRIDGE These are not as common as the French ones and are in serious decline overall. They are identifiable by the black badge on their breasts. Their nest is a scratched out hollow in the hedgerows. Although they lay huge clutches of eggs, if there are not enough insects around the chicks will not survive. Shooting farmers prefer the French variety because they remain in one area – the grey partridges move around covering a larger area.

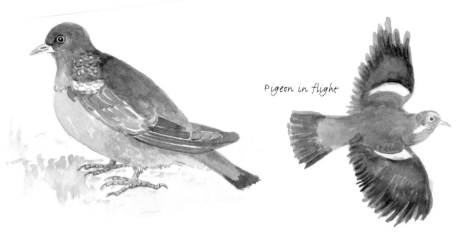

Pigeon in flight

WOOD PIGEON These birds are the enemies of farmers, flying around in huge flocks feeding on brassicas and oilseed rape in spring and summer and gleaning grain from the cornfields after harvest. They are larger than doves with a metallic blue-green sheen on the nape. They have a white collar and wing-bars.

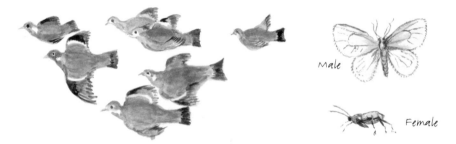

Male

Female

WINTER MOTH (*above right*) It is very common and is on the wing in early winter. The small green loopy caterpillars live on the young leaves of oak or fruit trees in early summer, sometimes stripping a small tree of leaves. They descend from the trees on silk threads and burrow into the soil to pupate. The moths hatch in November-December and crawl back up the tree trunks. They are mostly seen at night.

Dead Leaves

TREE CREEPER These are hard to see in their woodland habitat. They are well camouflaged as they creep in a spiral up the trunks of trees looking for insects which it prises from beneath the bark with its down-curved beak. It often makes its nest under the bark. Unlike the nuthatch it does not creep down the tree but flies down to the bottom of it or nearby one and starts climbing up again.

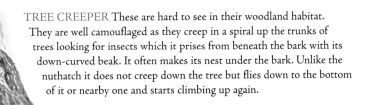

WITCHES' BUTTER Black gelatinous blobs found on dead branches, especially oak.

JEW'S EAR FUNGUS This is a jelly-like brown ear-shaped fungus often found on dead elder trees, looking like an ear with fine grey hairs on it.

BUTCHERS' BROOM This is a small evergreen shrub with spiky leaves. It has small green-white flowers from January to April. Large red berries grow out of the centre of the leaves in the winter months. They are usually found in dry woodlands. Its name 'Butchers' Broom' comes from its use in bygone days by butchers who found the stiff prickly leaves very good to clean and scour their wooden chopping blocks.

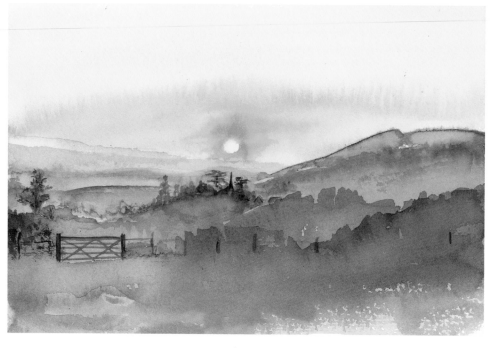

*A misty sunrise*

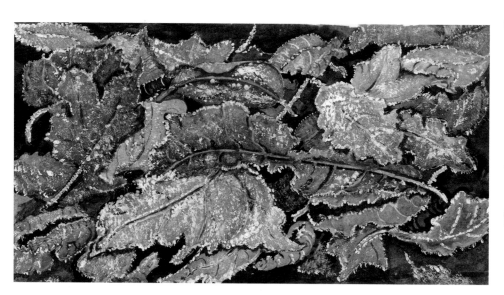

*A touch of Frost*

*'so there's my year, the twelvemonth duly told'*
*Harvest*: Edmund Blunden

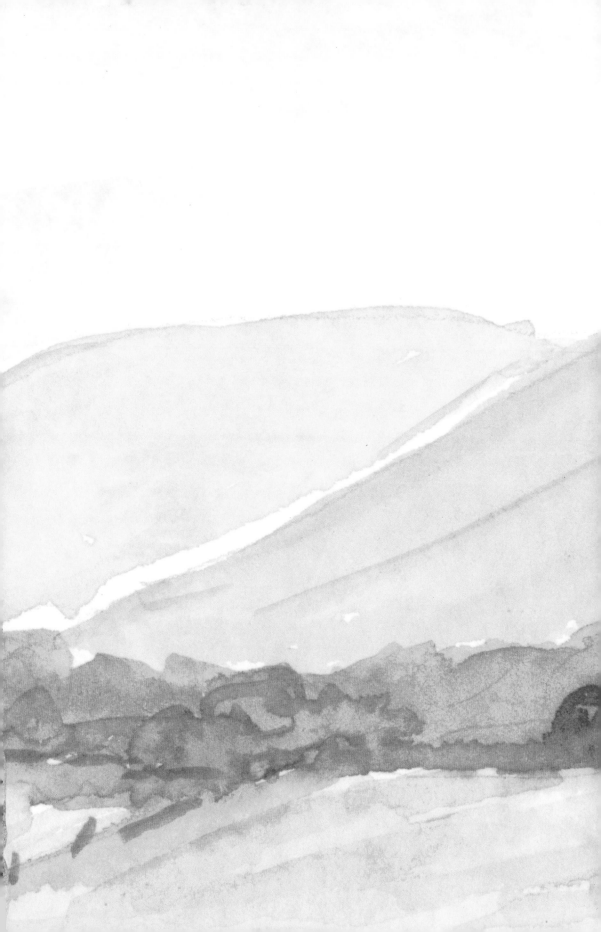

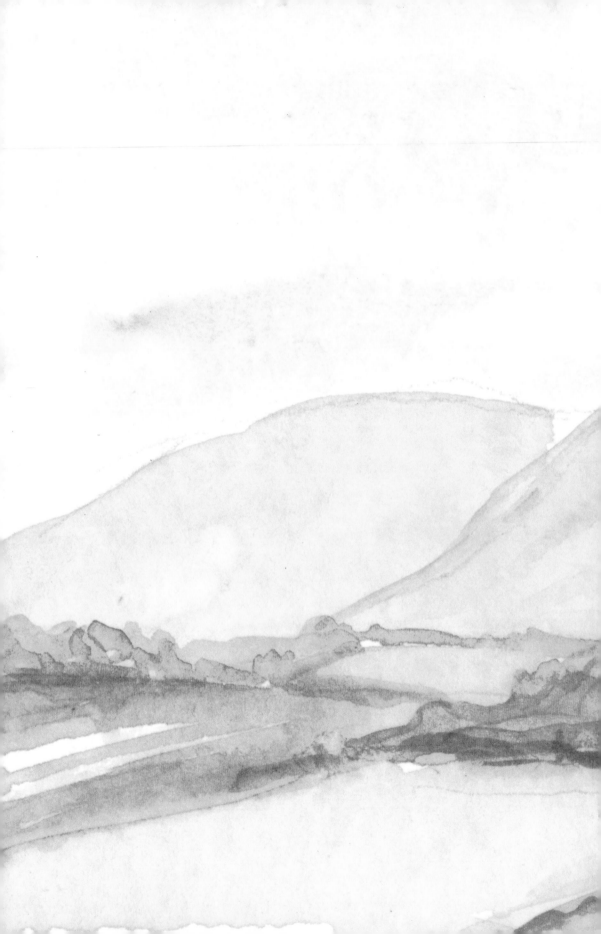